Relaxing Geometric Designs and Patterns
Coloring Book for Adults

Carmen Alfaro

Relaxing Geometric Designs and Patterns by Carmen Alfaro

Copyright © 2016 Inspiring Expression LLC.

All rights reserved. No part of this book may be reproduced in any written, electronic, recorded, or photocopied form without written permission of the author. The scanning, uploading, and electronic sharing of any part of this book without permission of the author constitutes unlawful piracy and theft of the author's intellectual property.

www.InspiringExpressionDesigns.com

First Edition: 2016

10 9 8 7 6 5 4 3 2 1

ISBN-13: 978-1539032182

ISBN-10: 1539032183

Dedication

To my husband, your love and encouragement helped me bring this book to life!

I also want to dedicate this book to everyone who wants their dreams to come true. In the end you'll only regret the risks you didn't take. Let go of your fears, believe in yourself and go for it!

Relax as you enter the world of geometry...

This coloring book is your own journey through the wonderful world of surreal geometric figures. Here you will find a place to escape your everyday routine and let out your creativity. There are no rules or boundaries here, so your inner child is free to come out and play. No need to stay within the lines or having to use matching colors. YOU make the rules here!

Not only is coloring fun, but it's also a very relaxing activity to enjoy at any time. The magic of coloring happens when you let go of your worries and concentrate solely on being fully present as you color each figure. In a way it's like a type of meditation in motion.

In this book you'll find 41 designs that range from simple to very complex. Every design has been created to expose a different side of geometry. Some pages have more circles, others have squares, triangles, hexagons, etc. or a combination of all of them.

Take your time and enjoy yourself as you color each design. Now let your stress melt away as you enter the wonderful world of geometry...

Test page

Here you can test different colors to see which one you like best. If you use markers or gel pens for coloring your pages, then here's a tip: Put some extra computer paper in between the pages so it doesn't "bleed" out. Have lots of fun coloring!

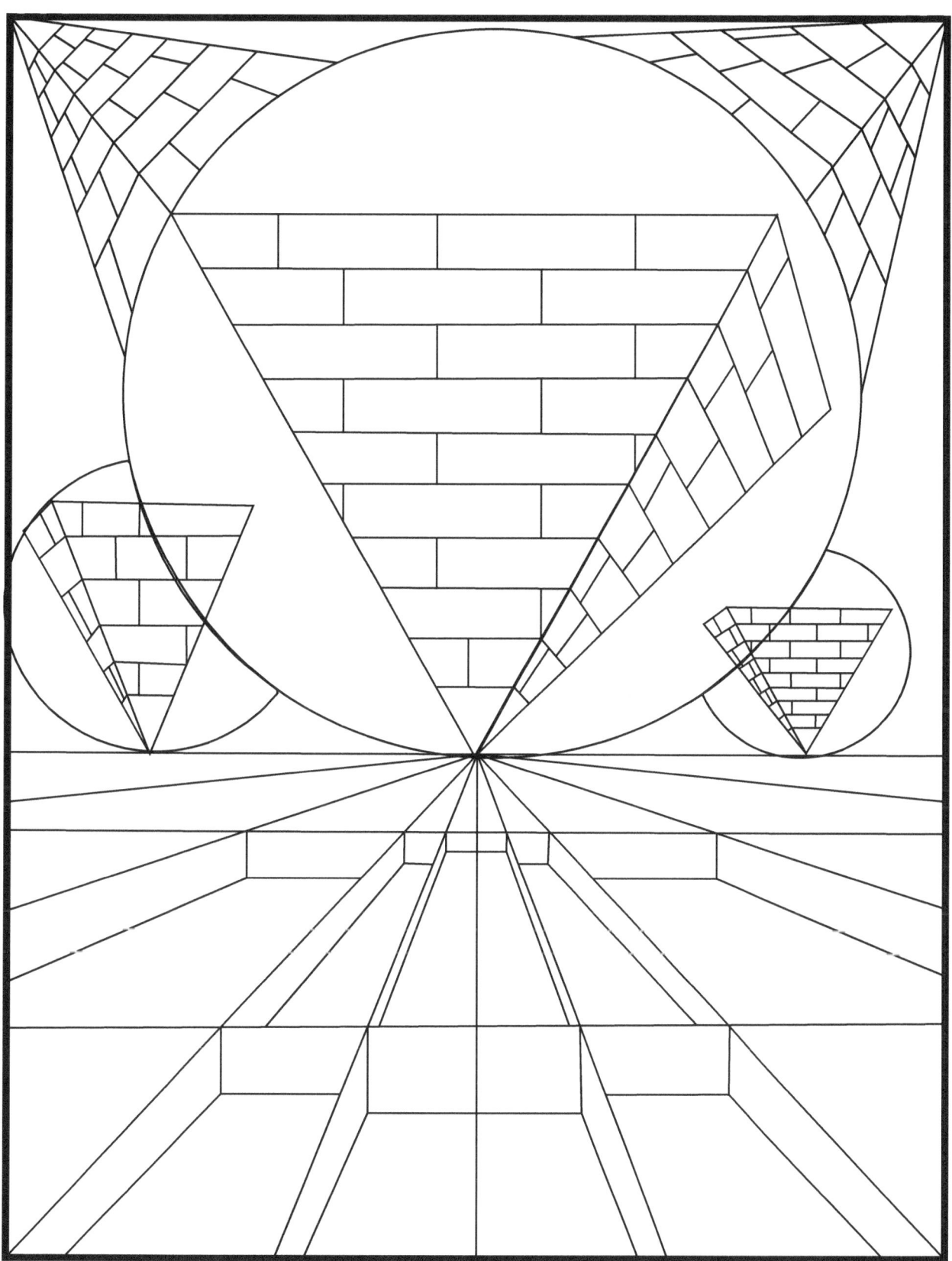

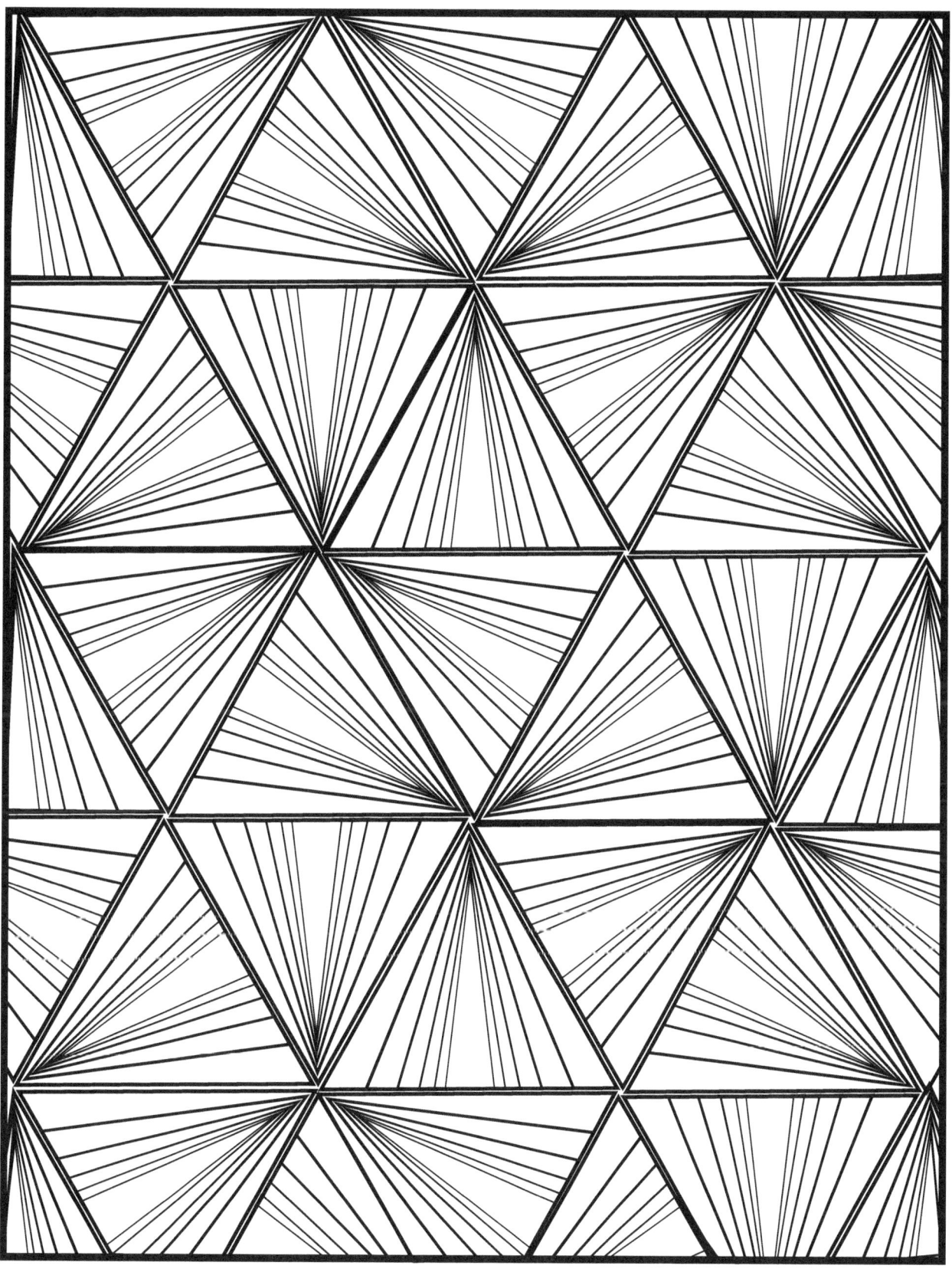

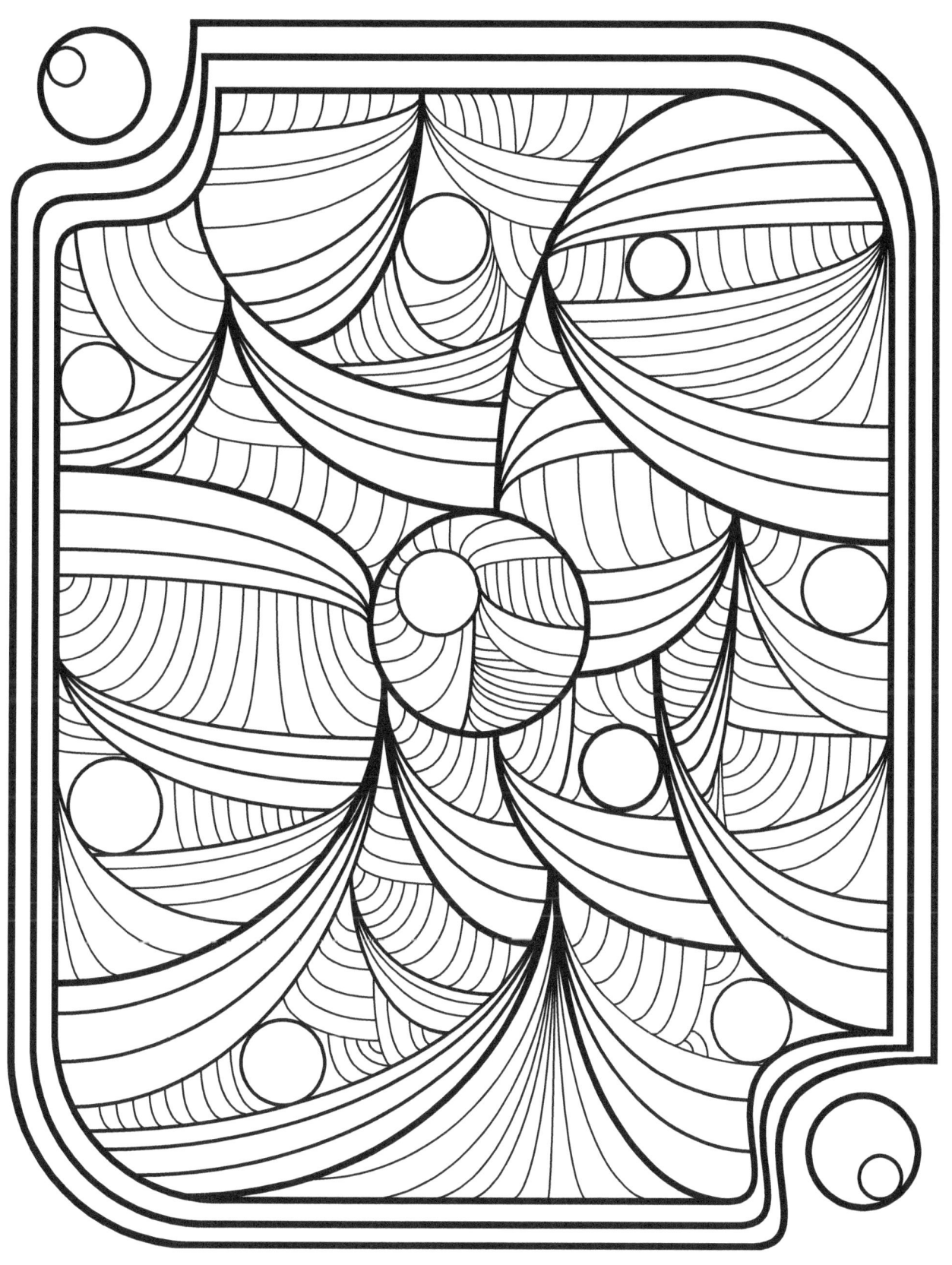

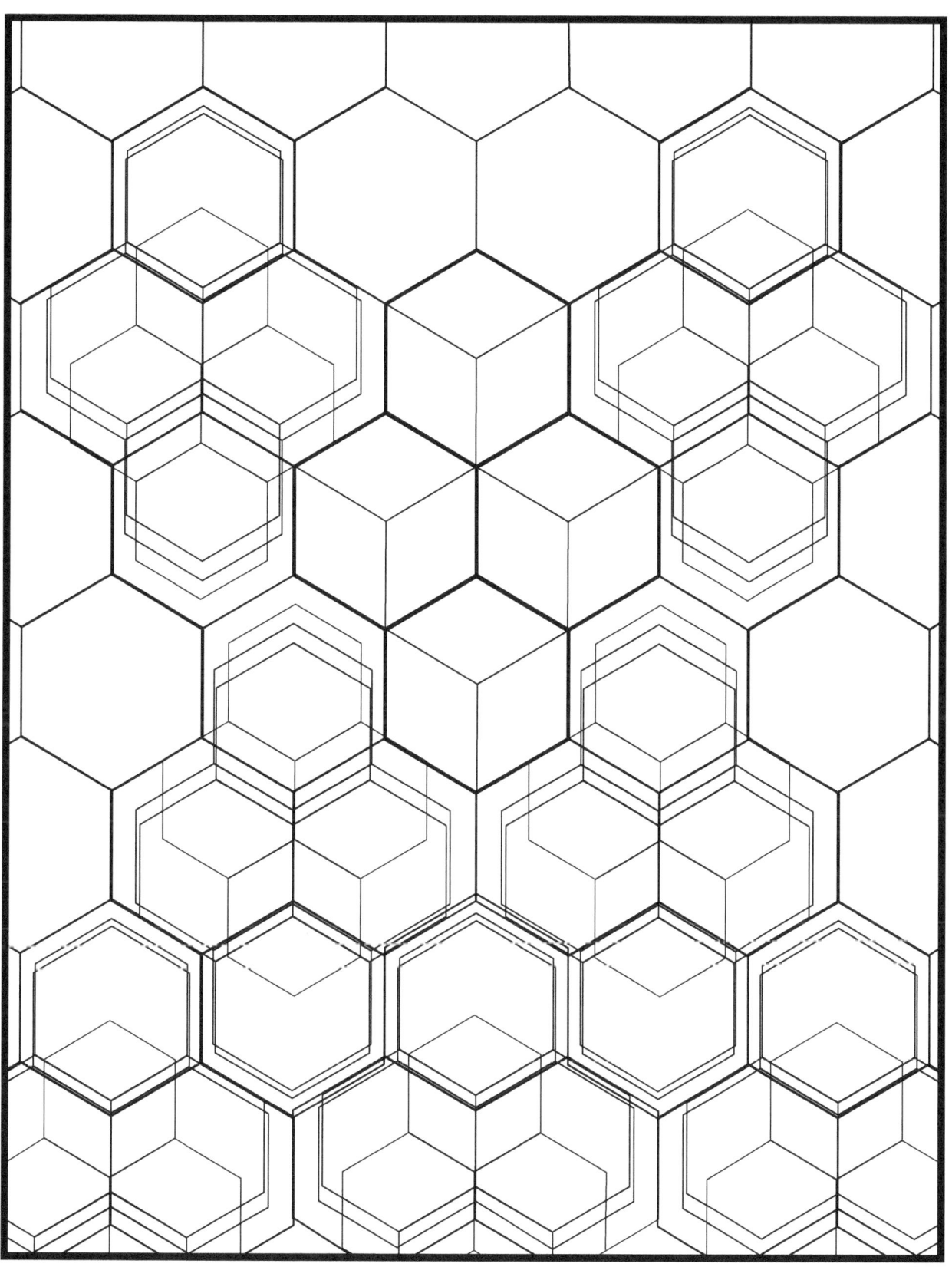

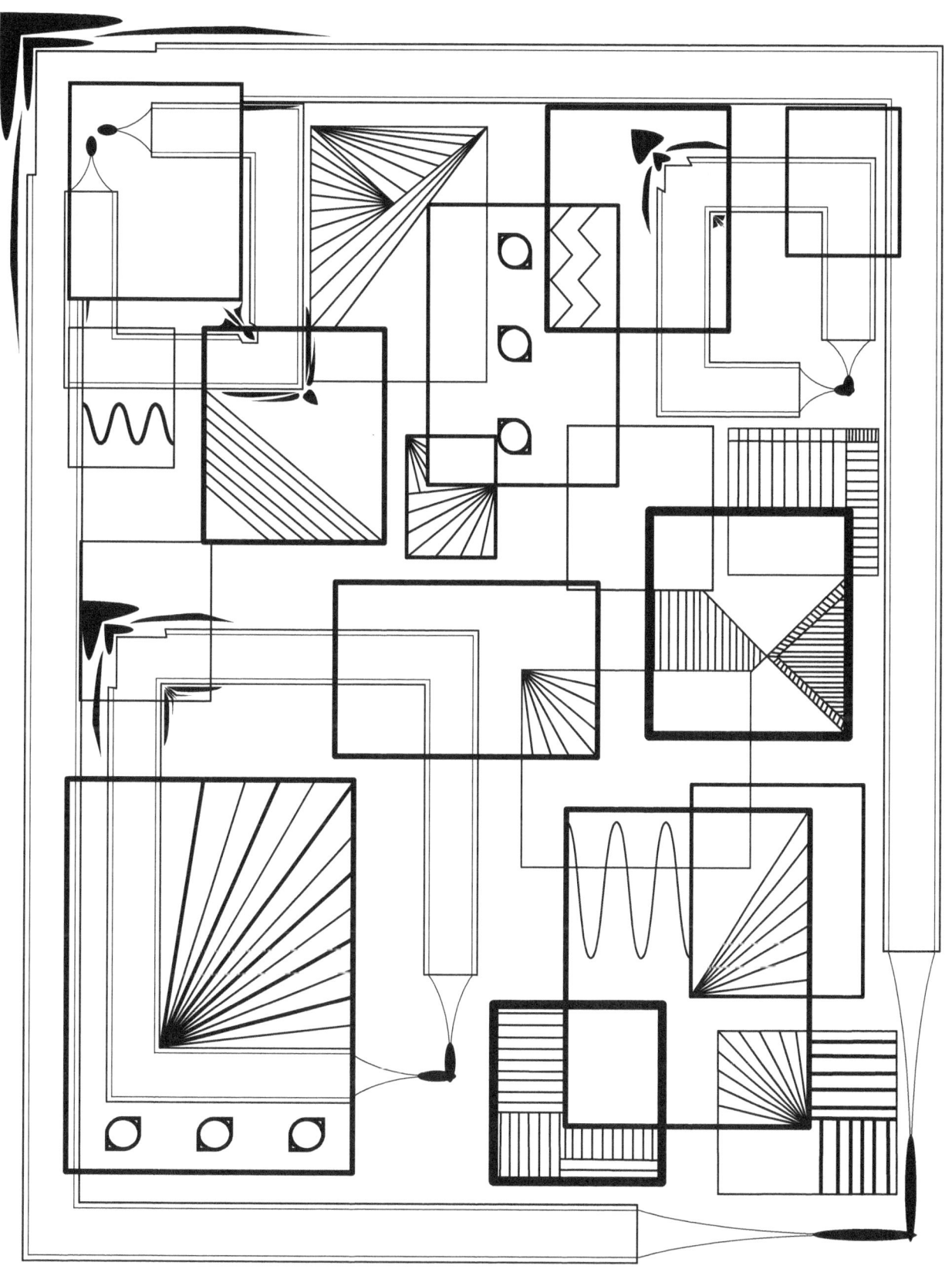

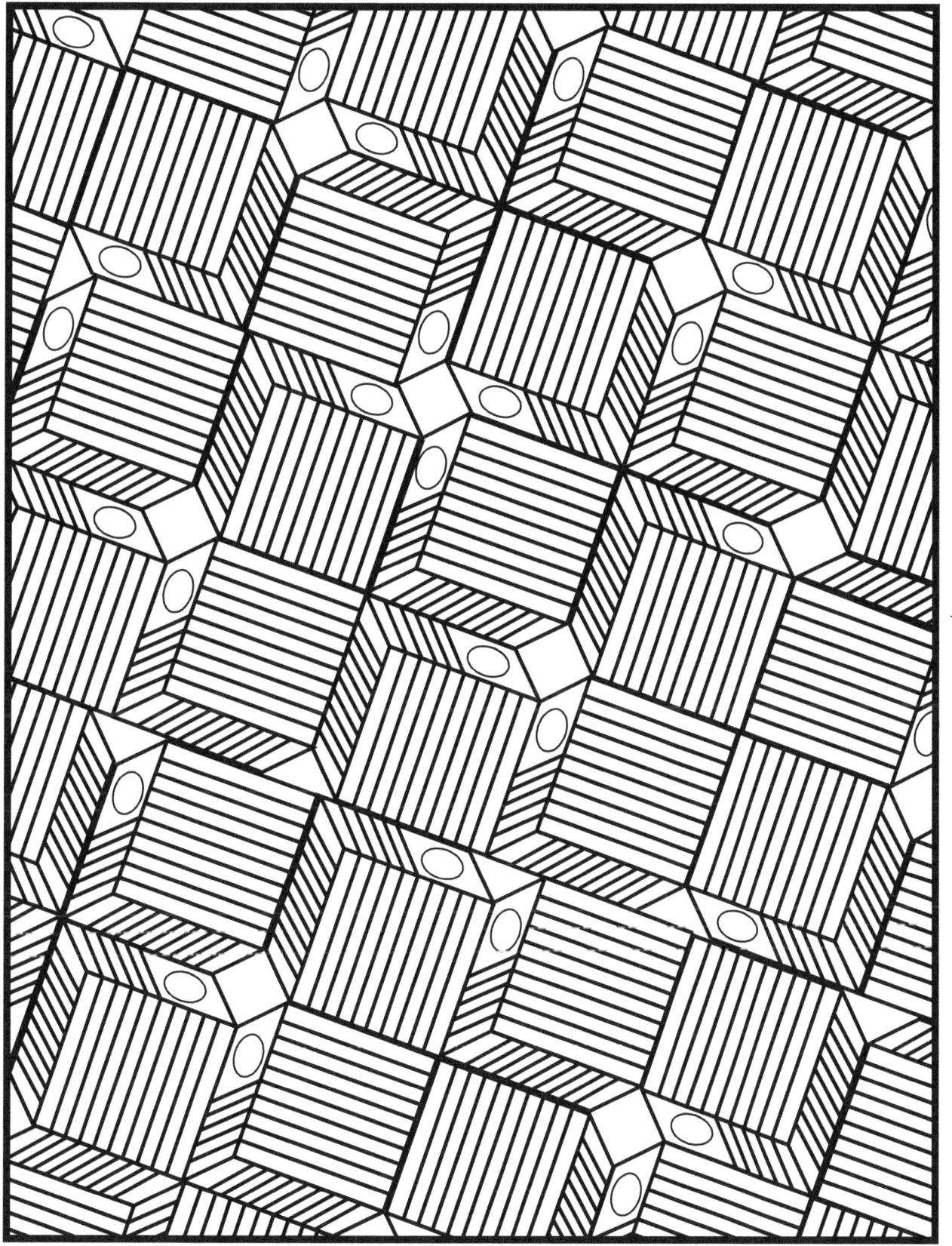

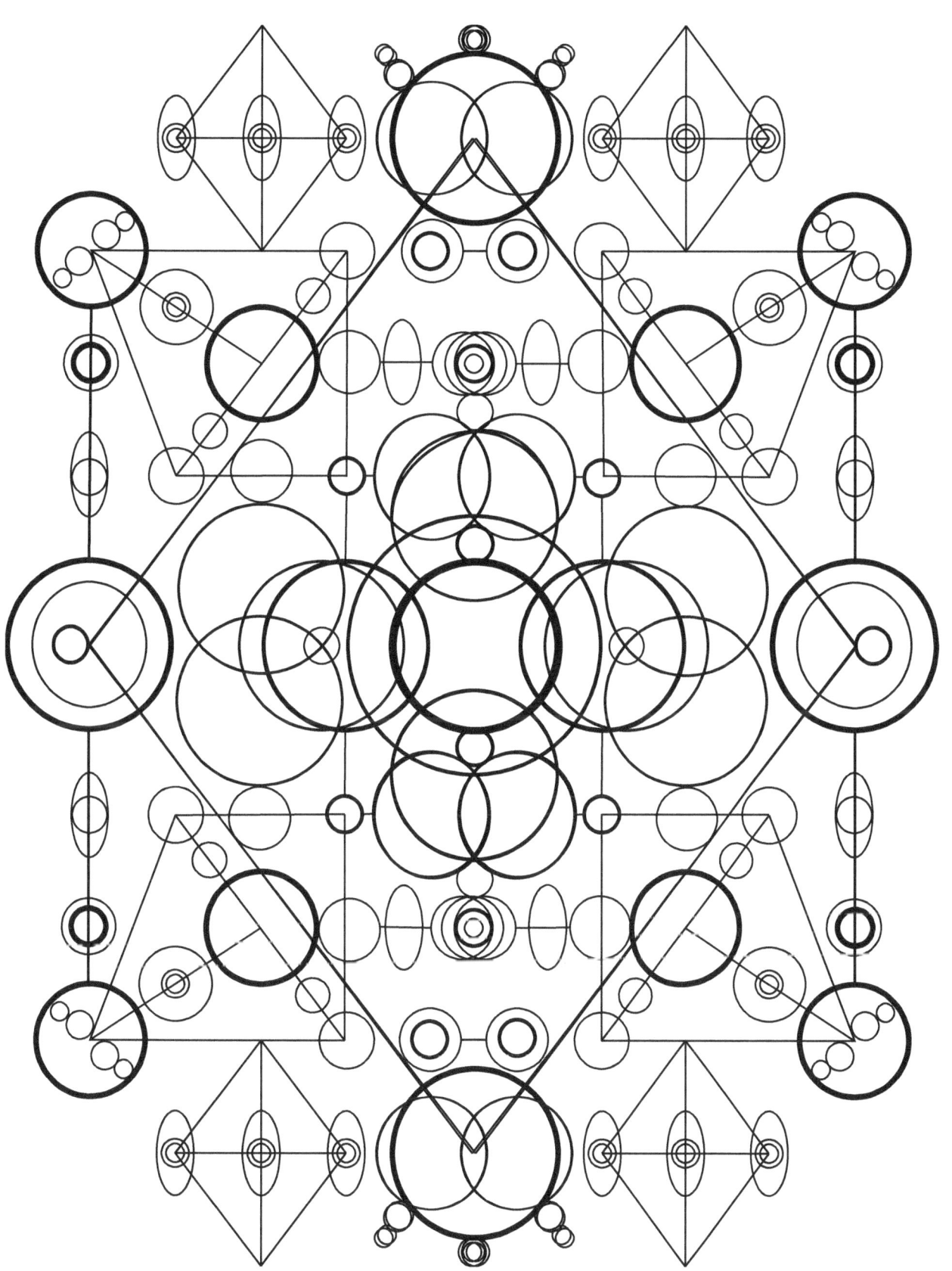

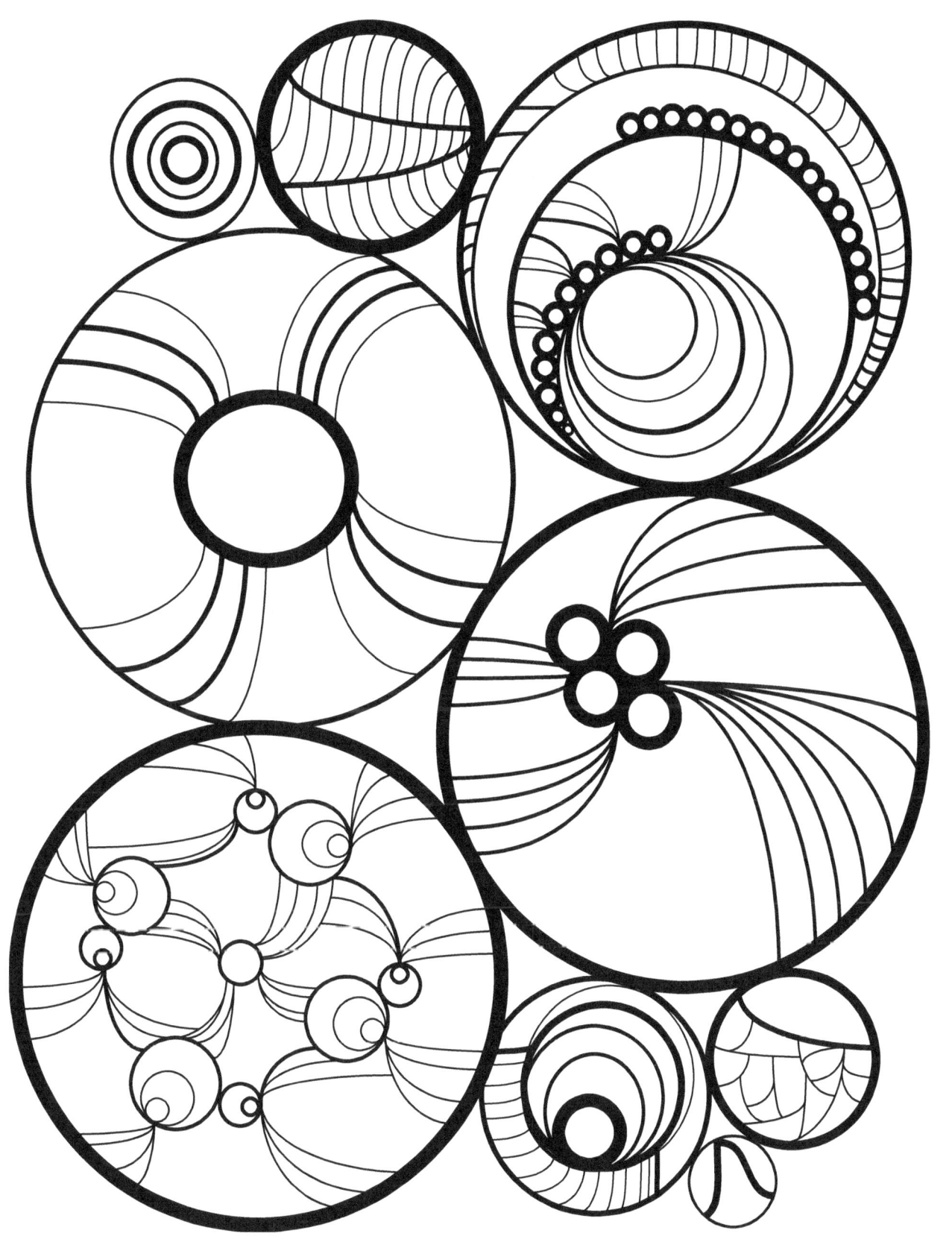

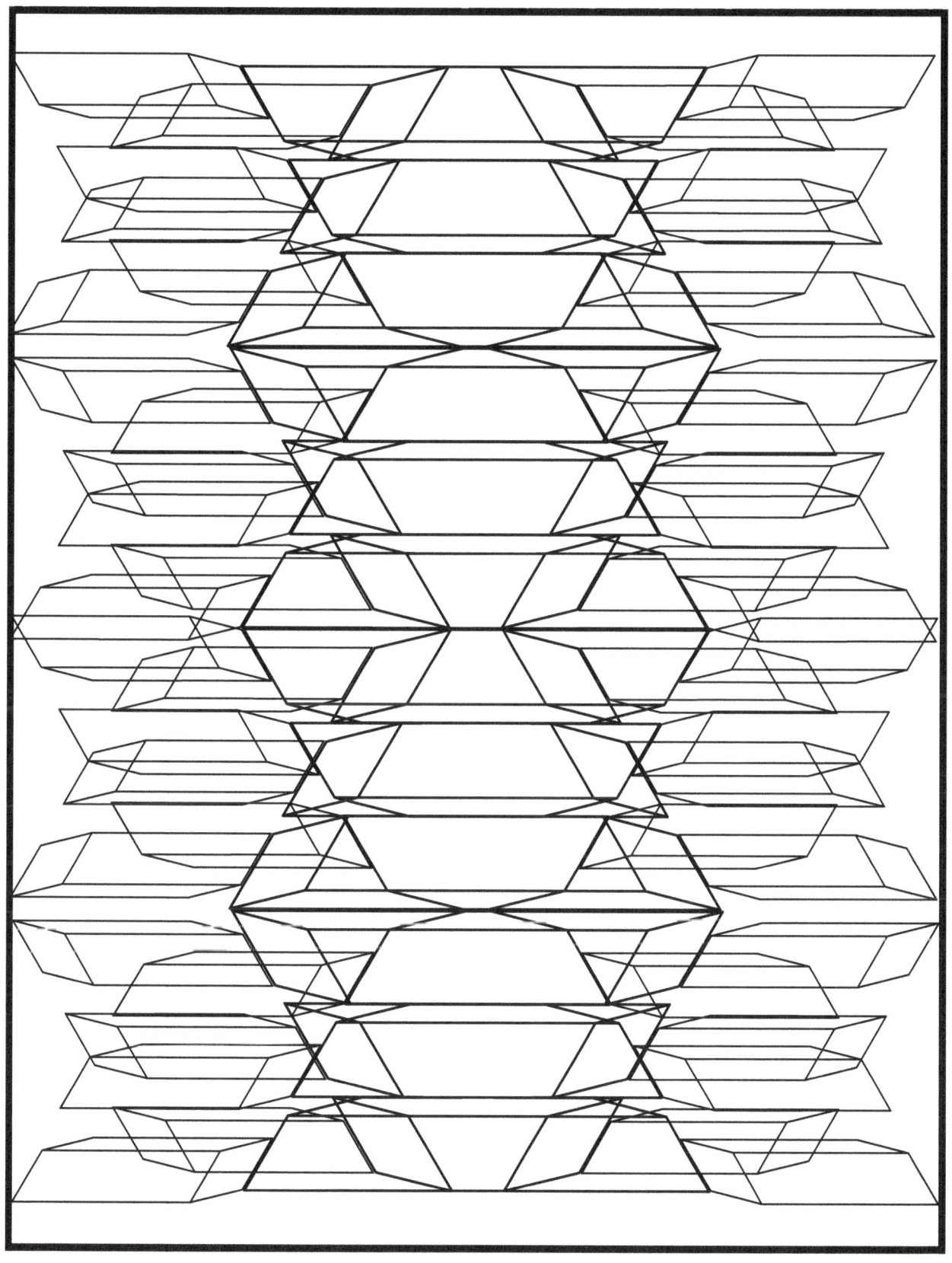

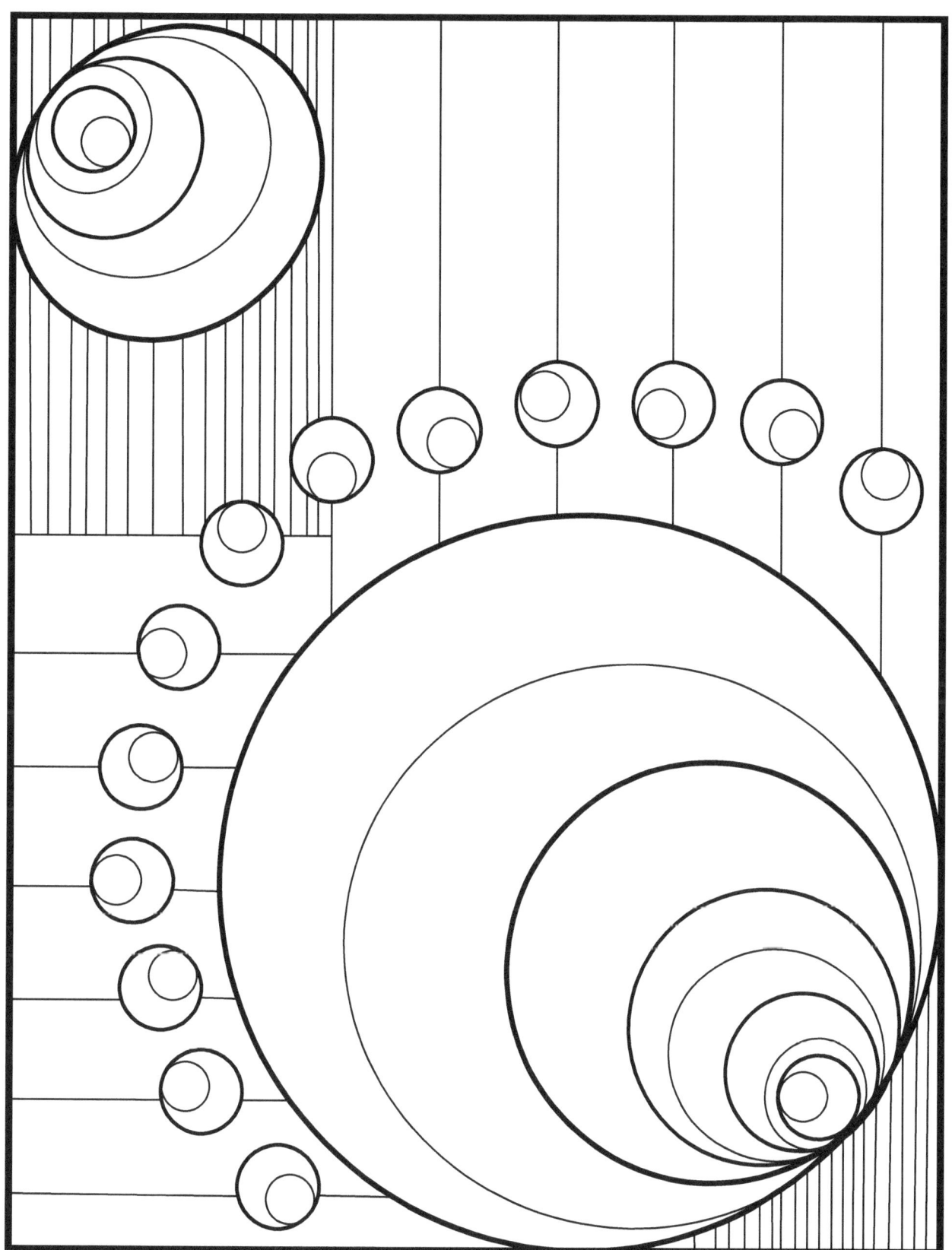

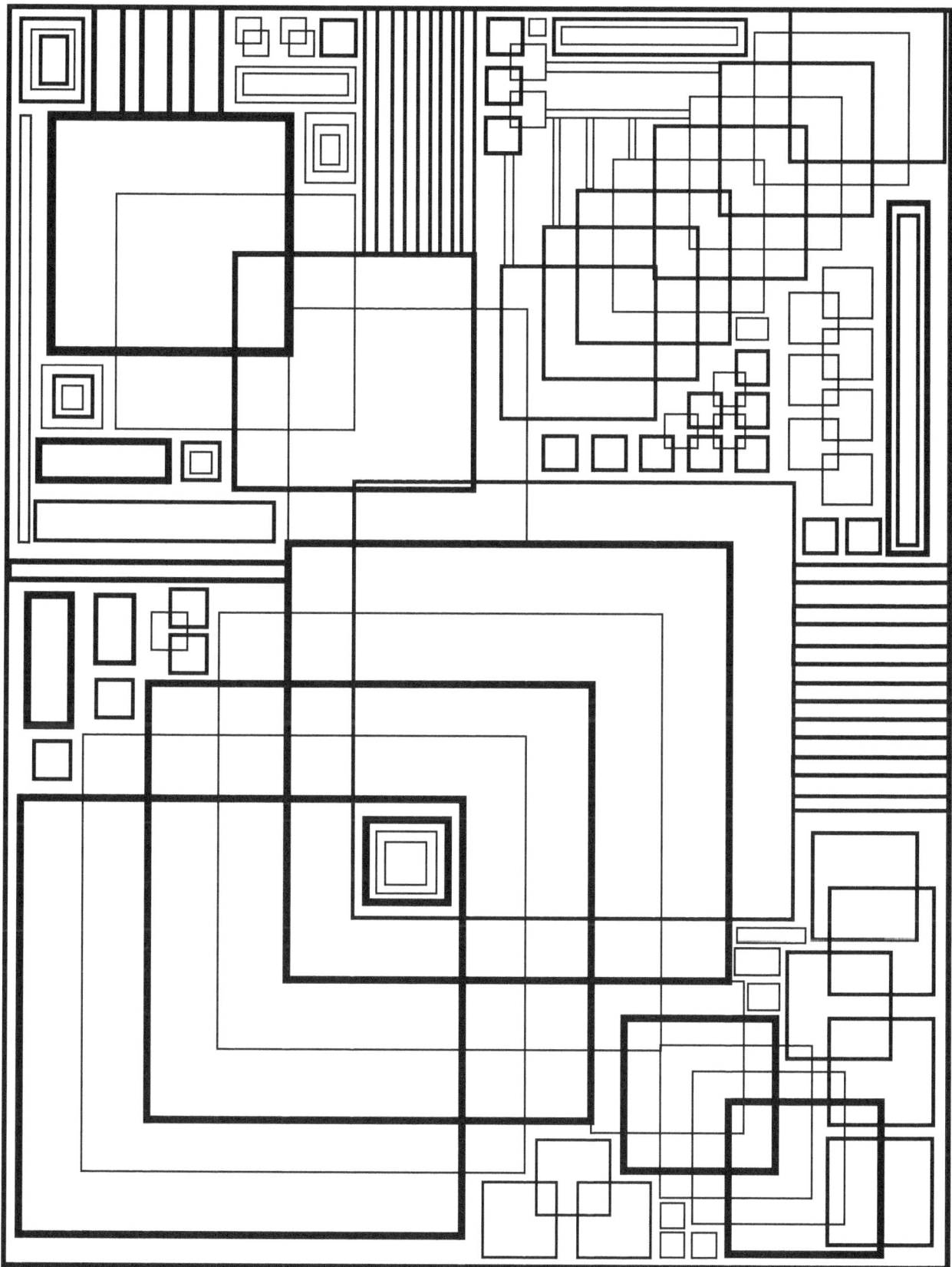

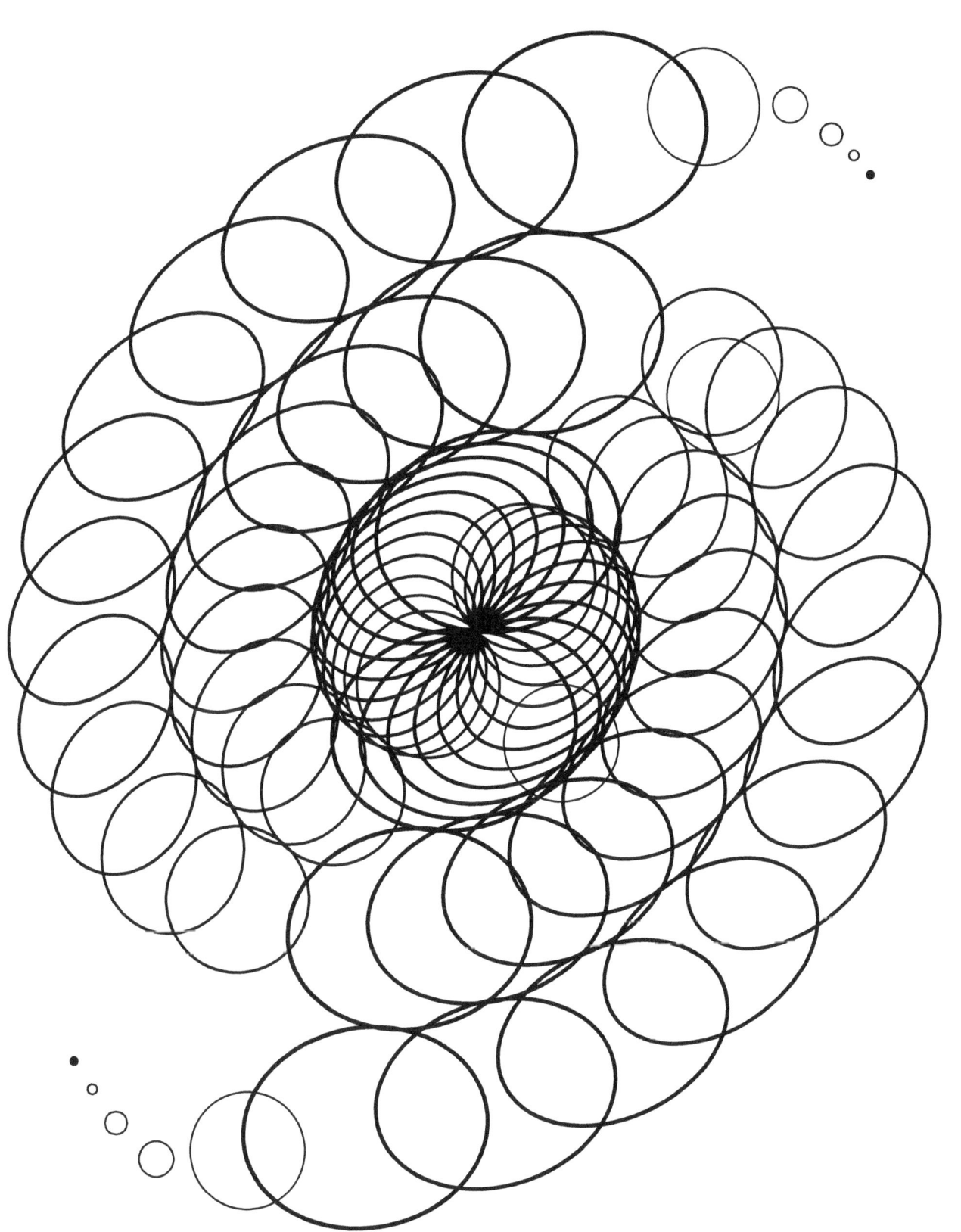

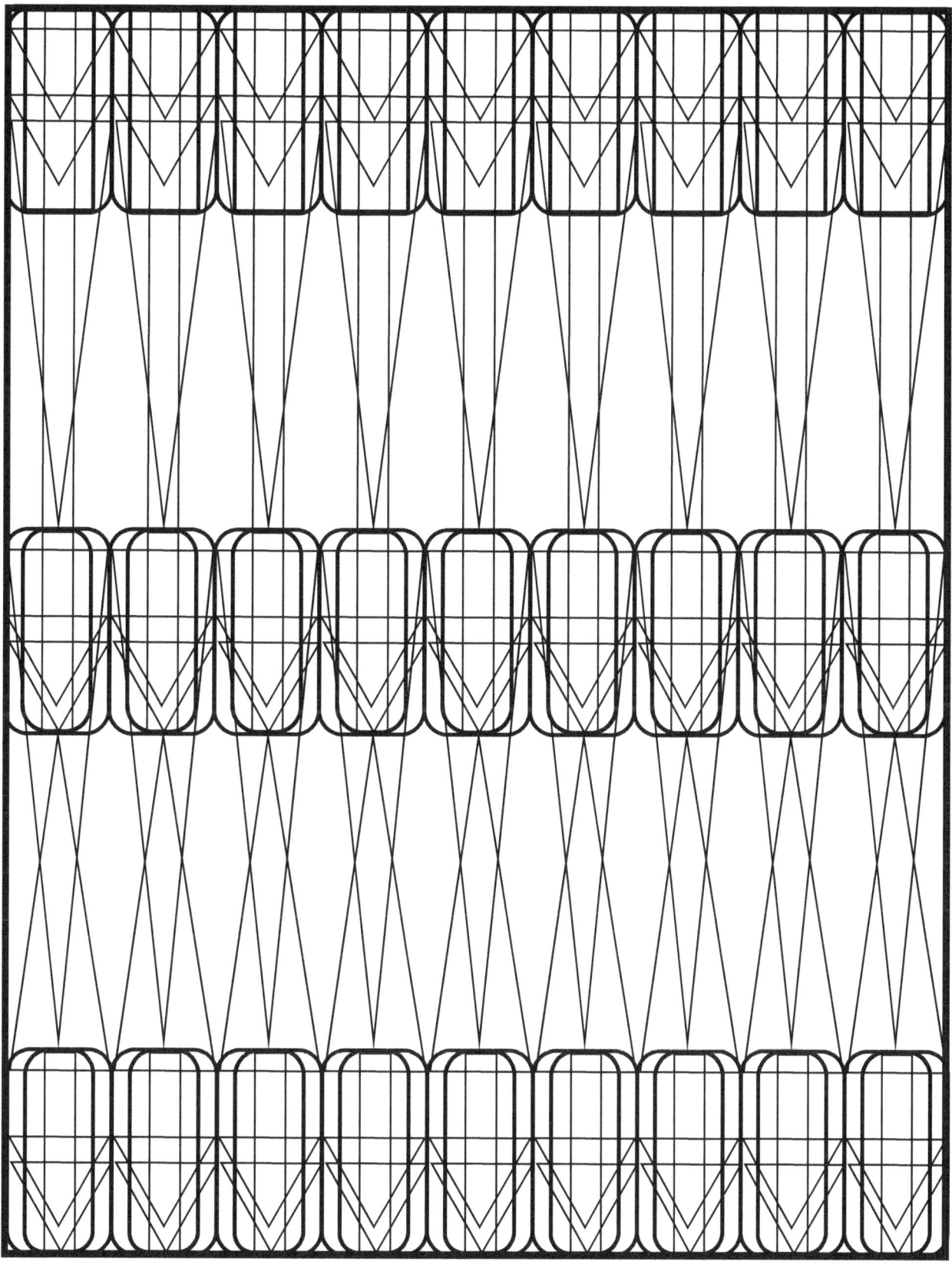

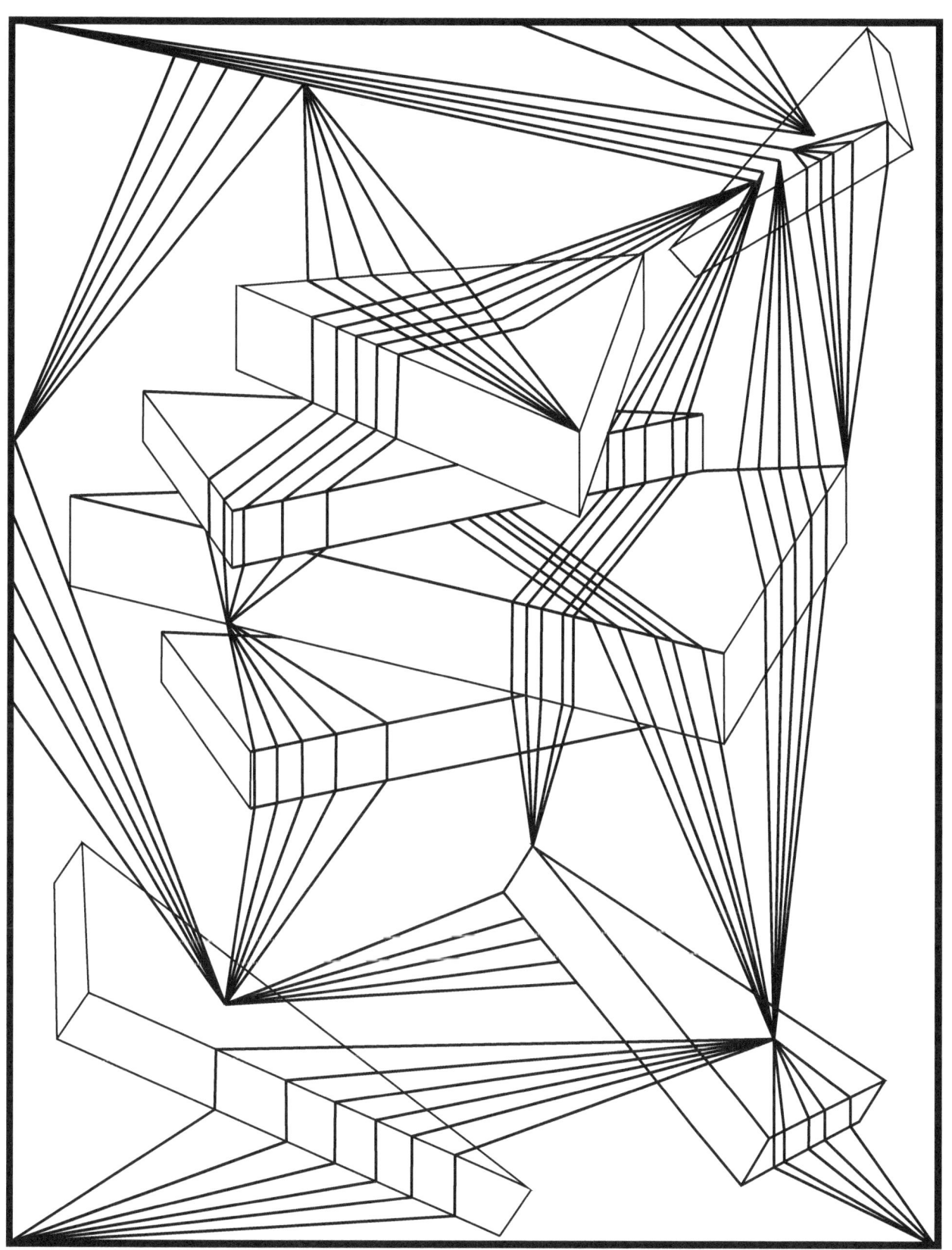

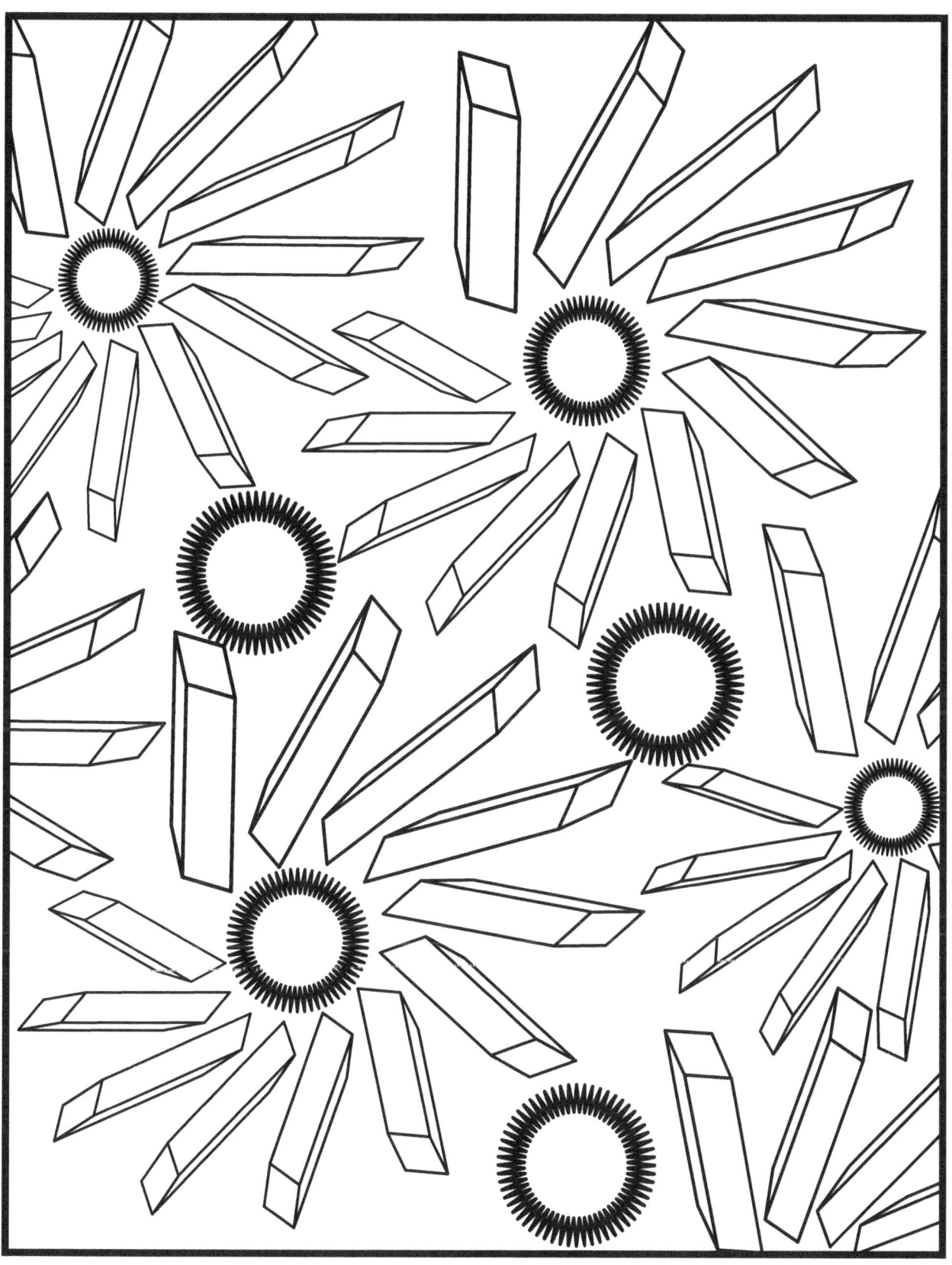

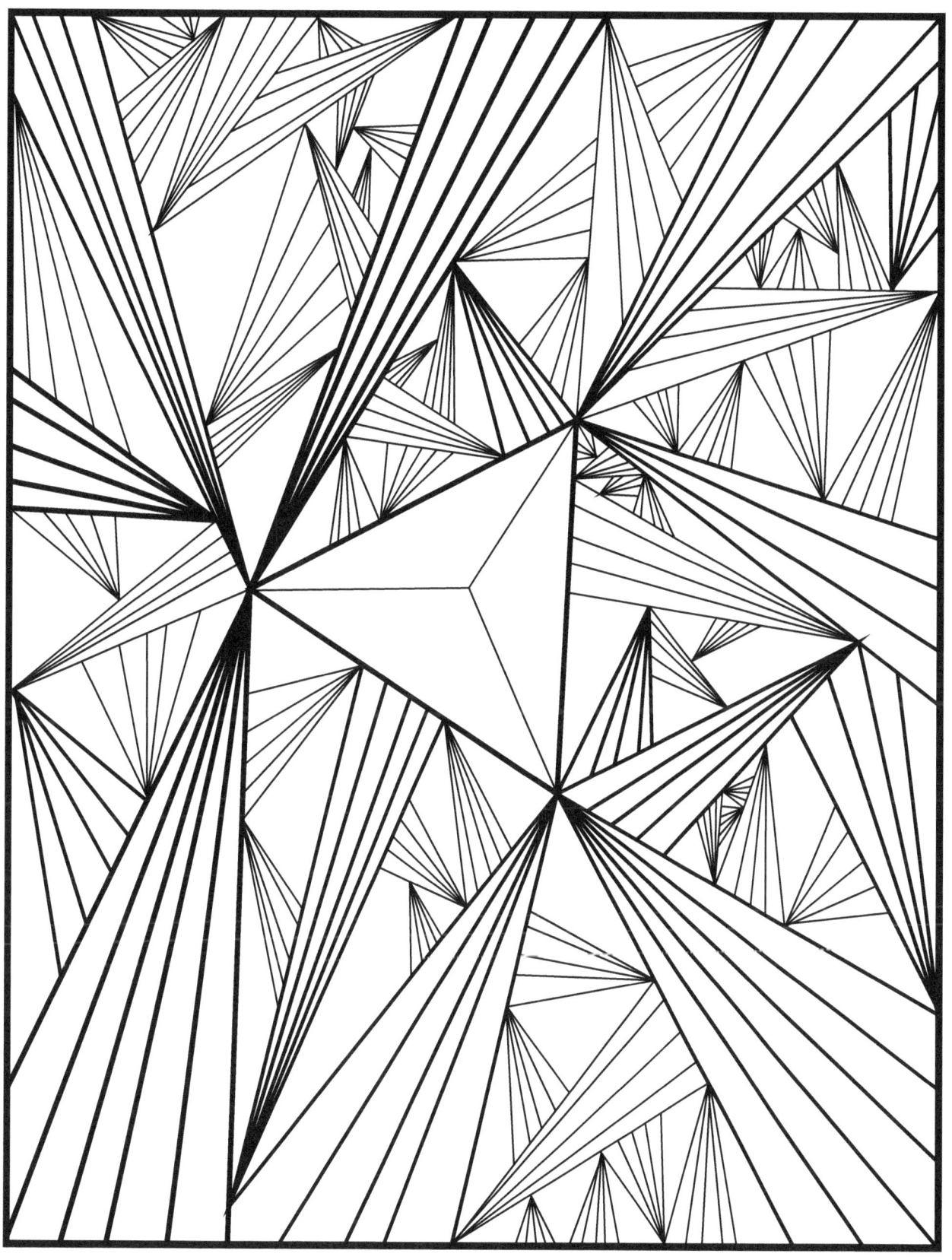

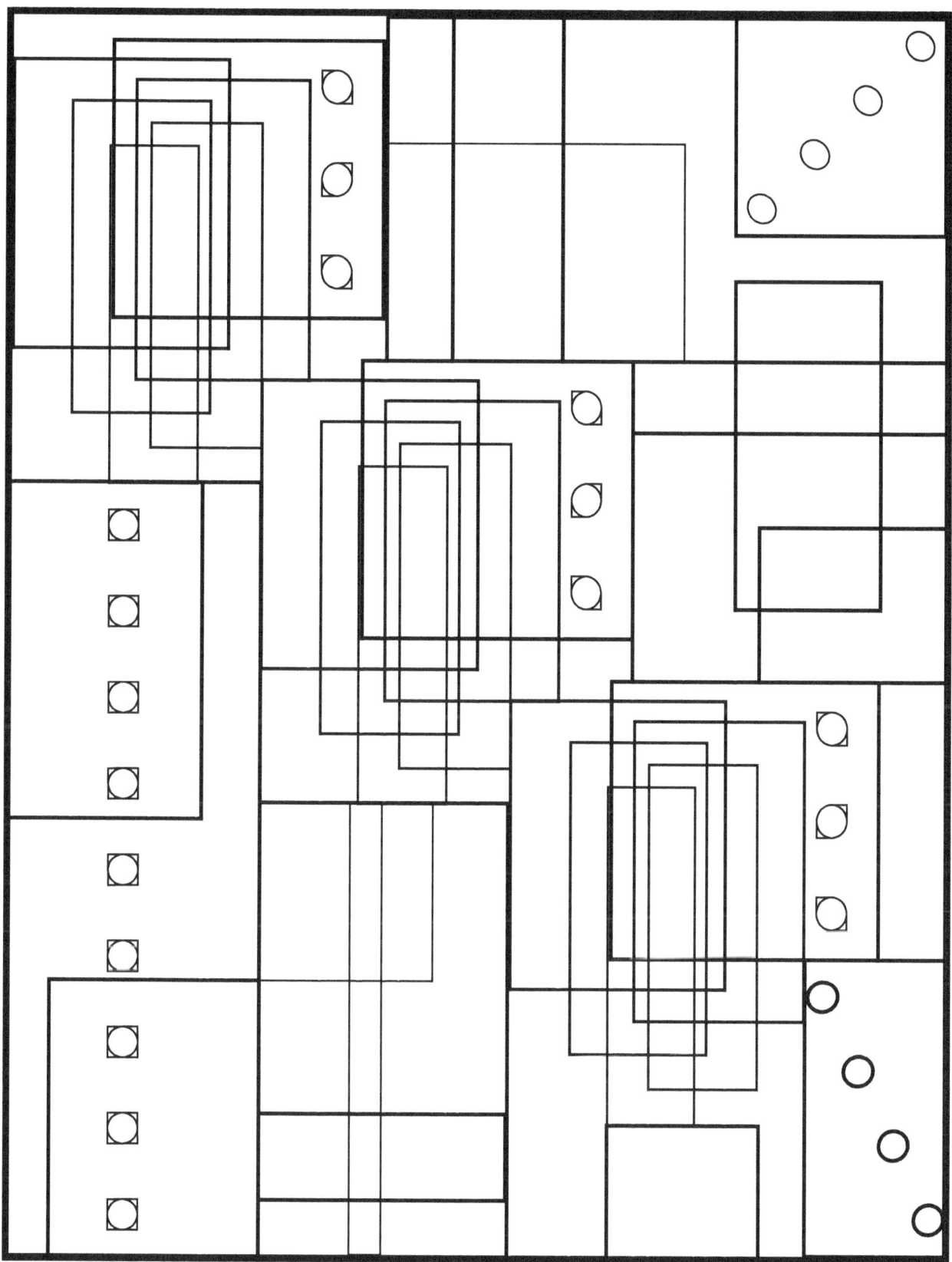

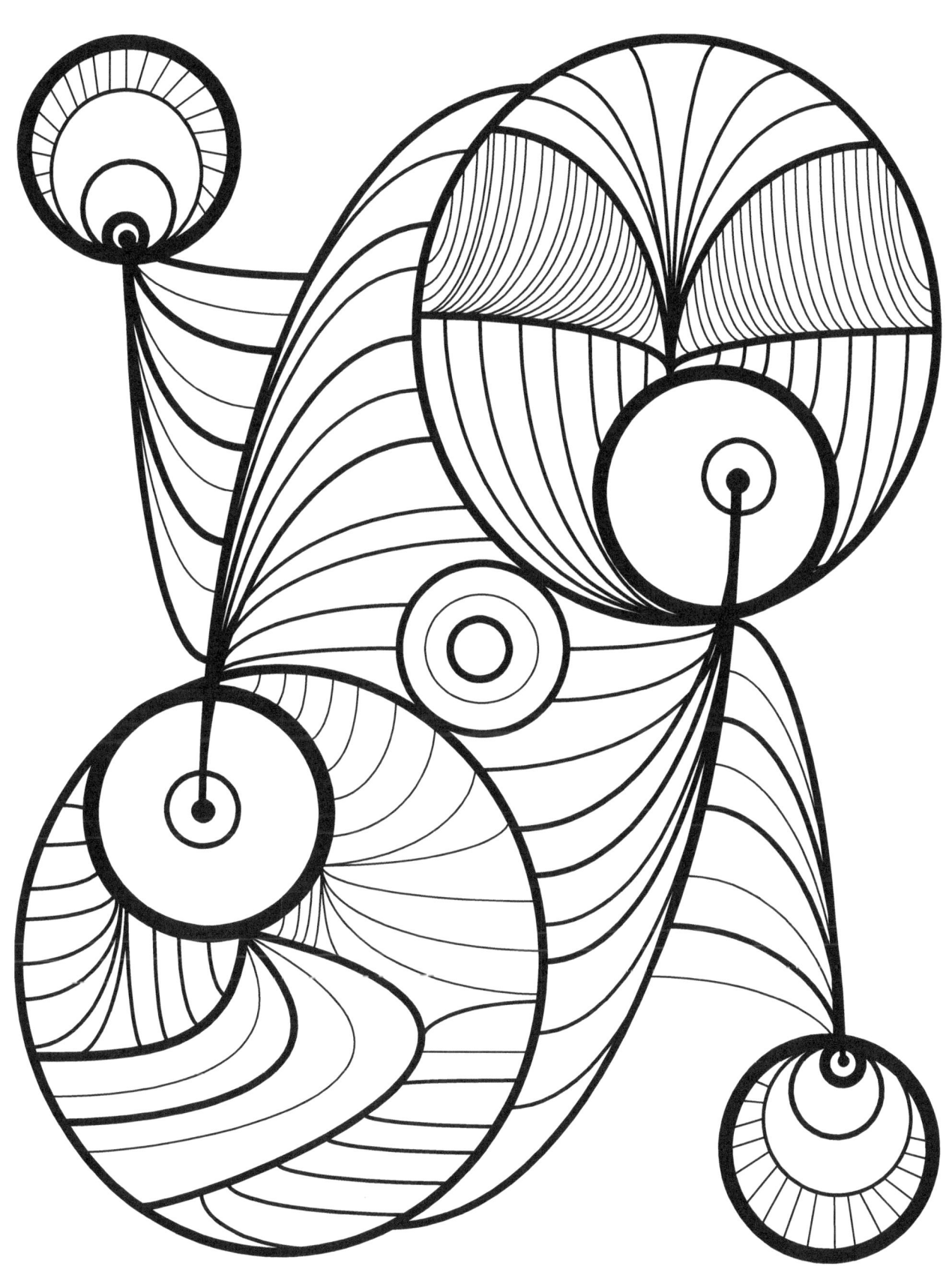

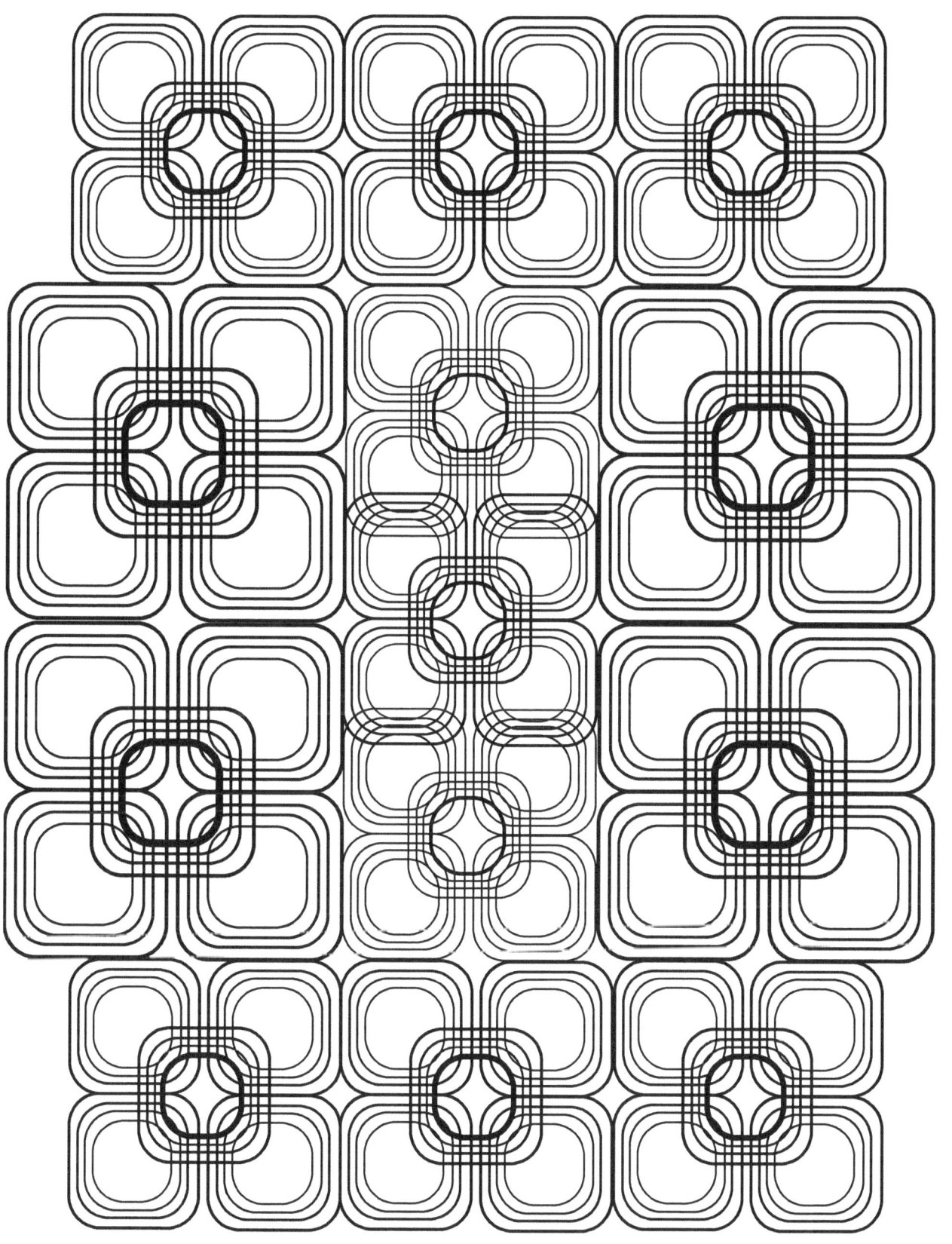

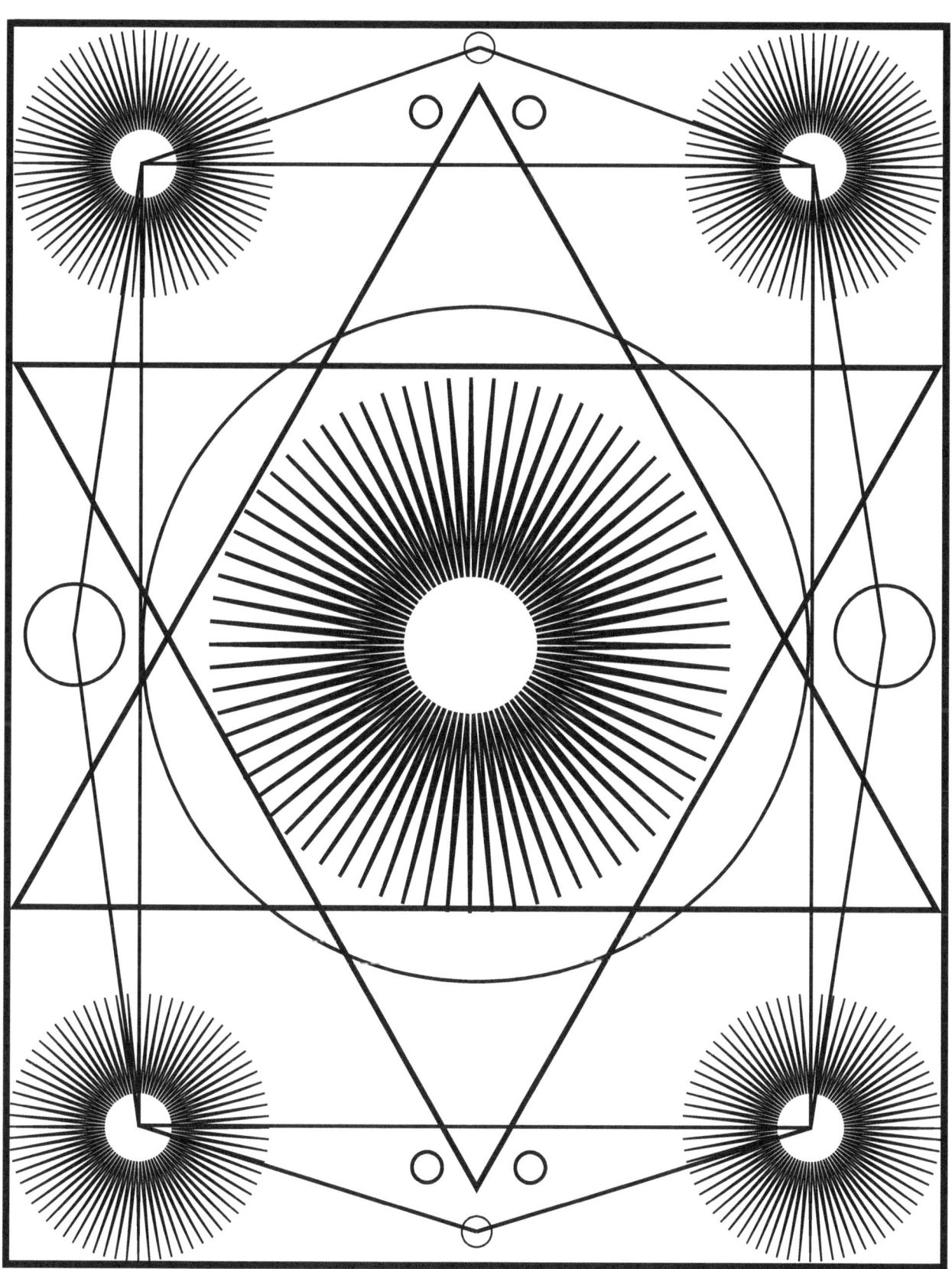

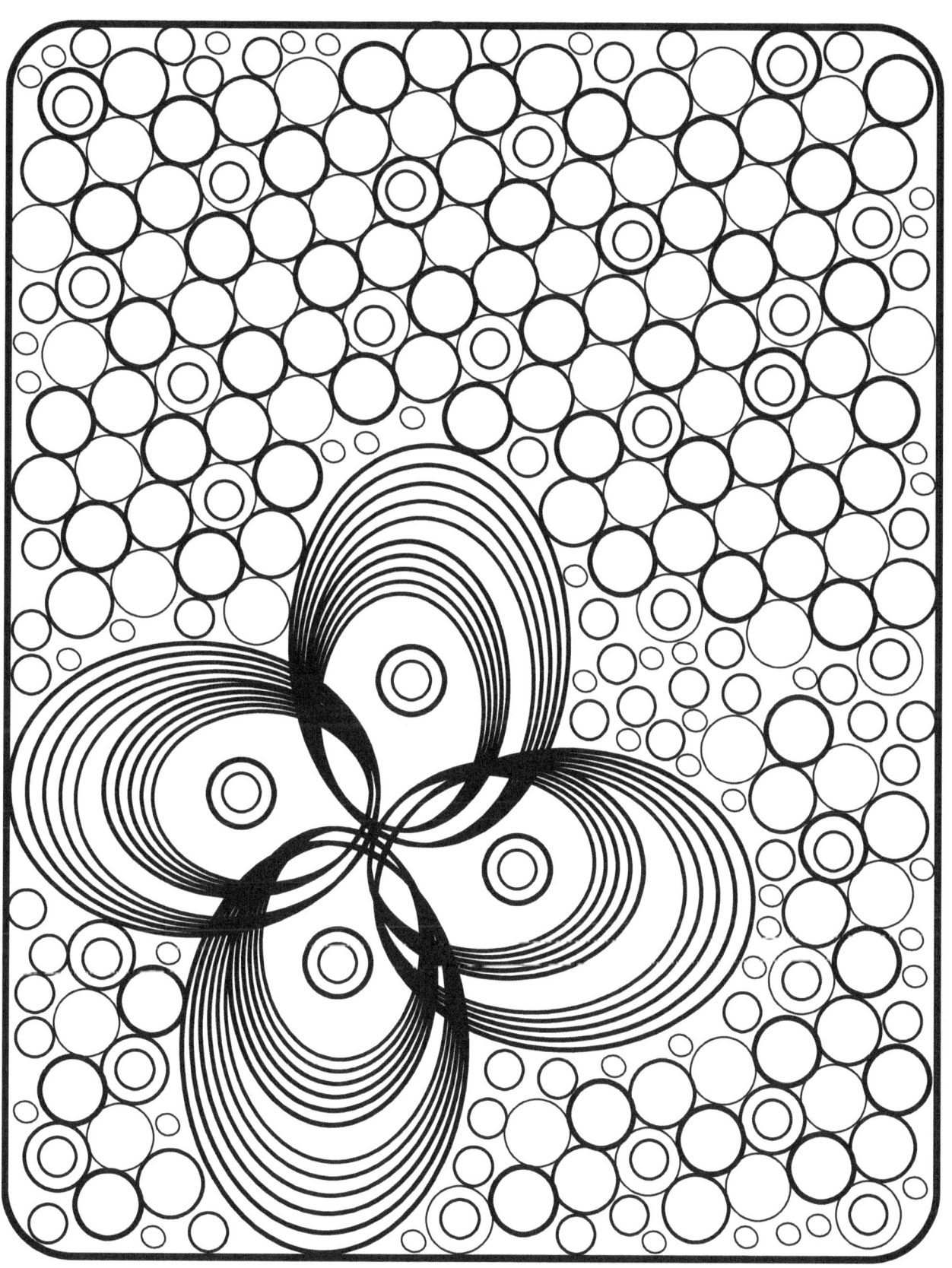

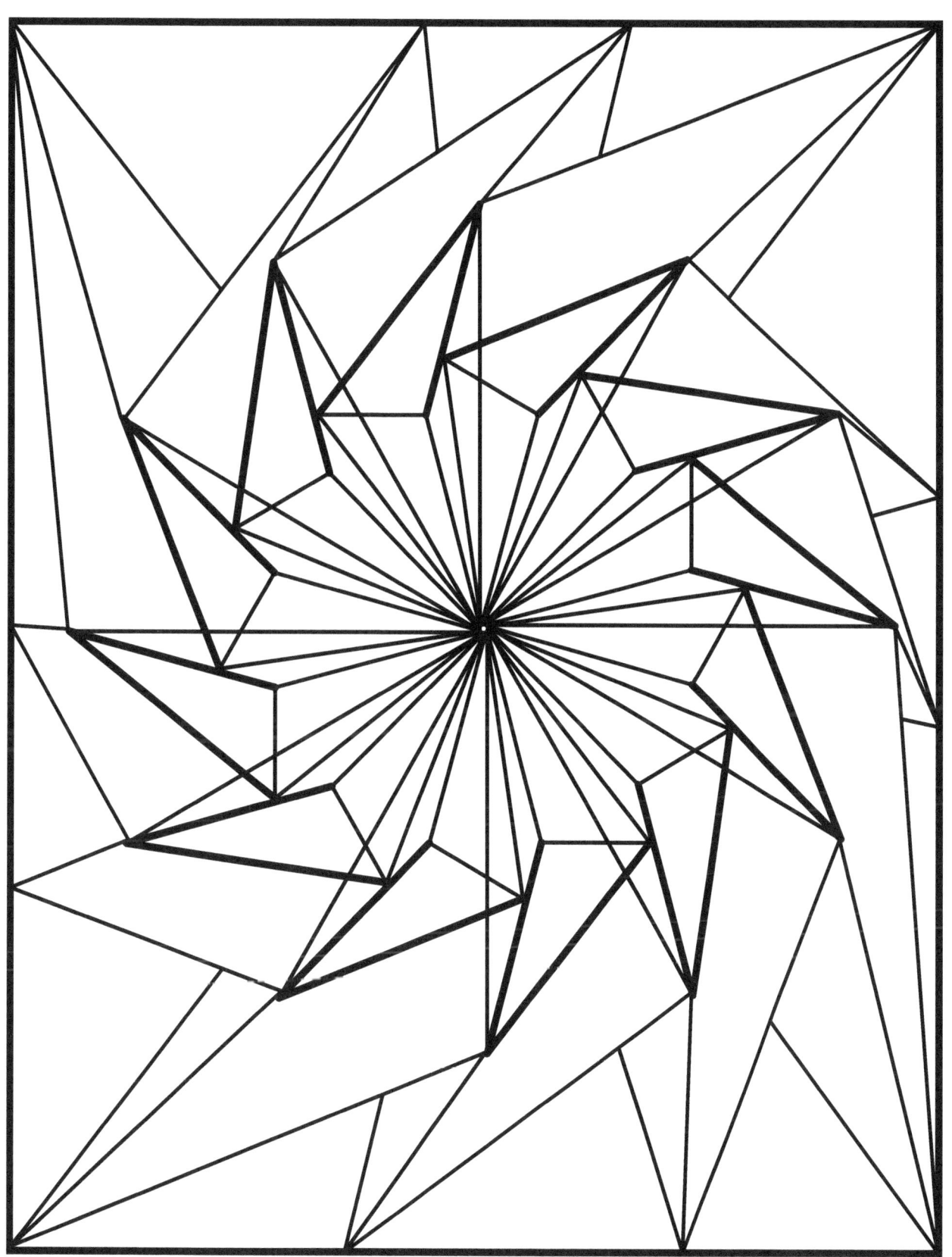

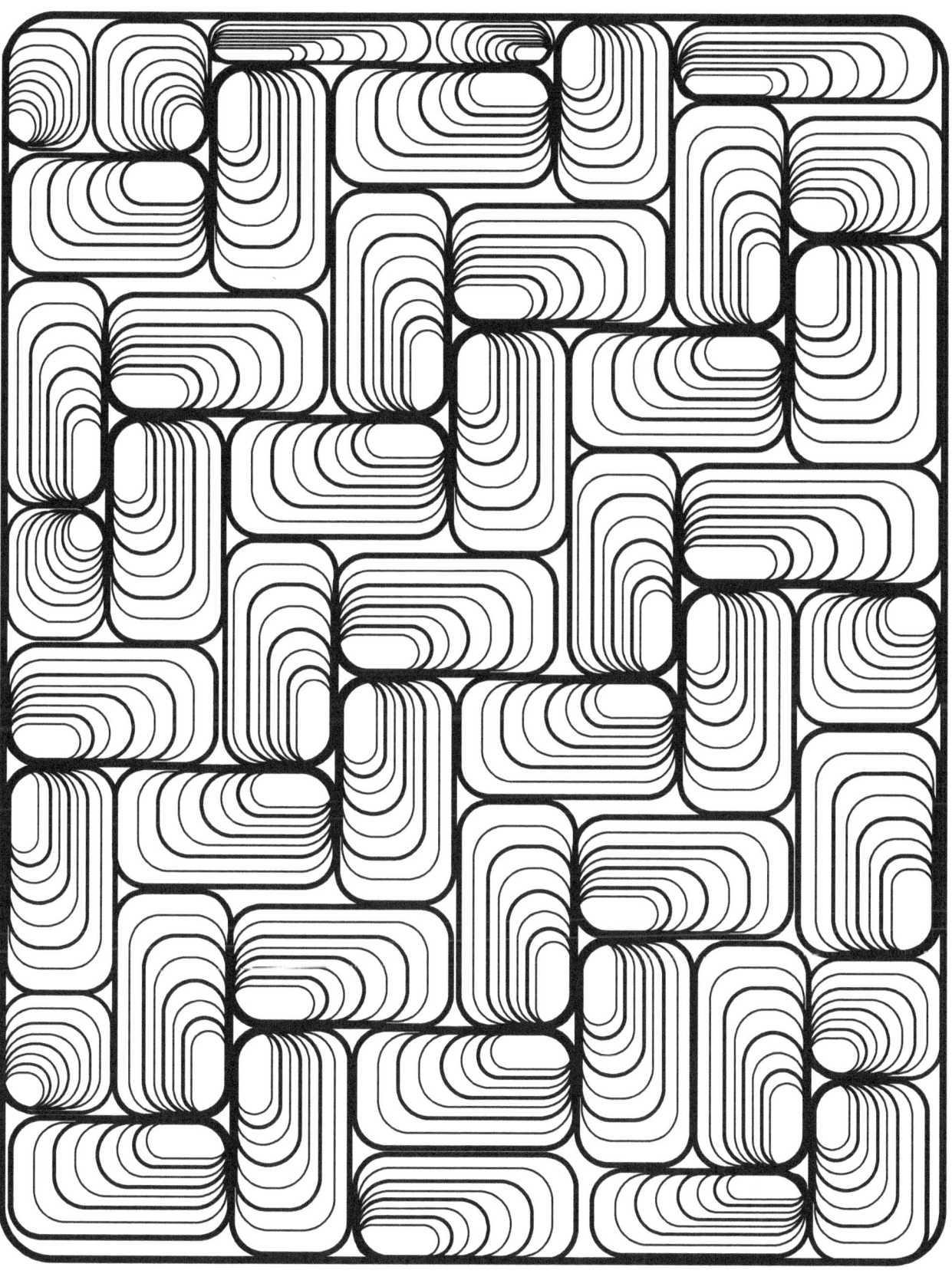

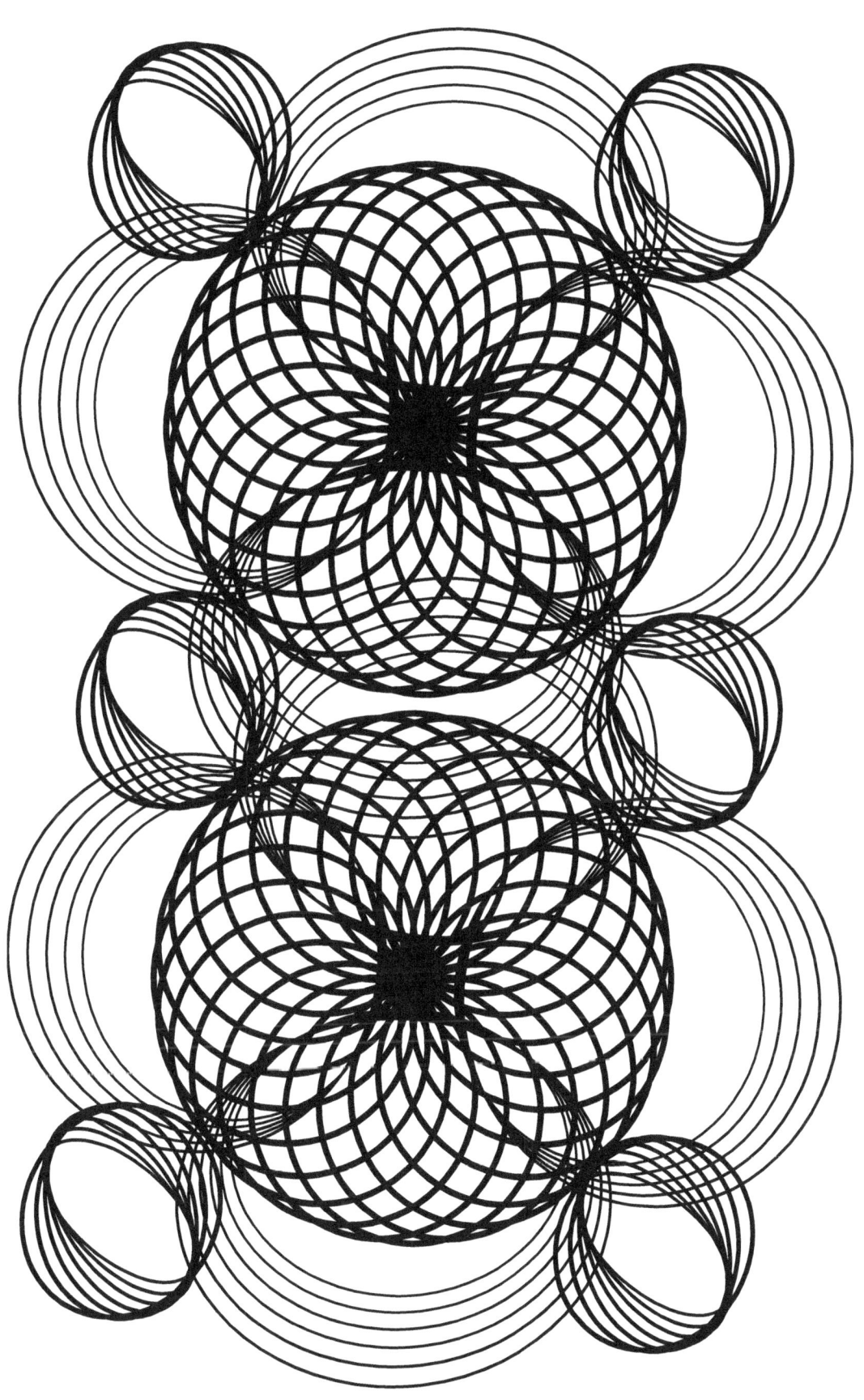

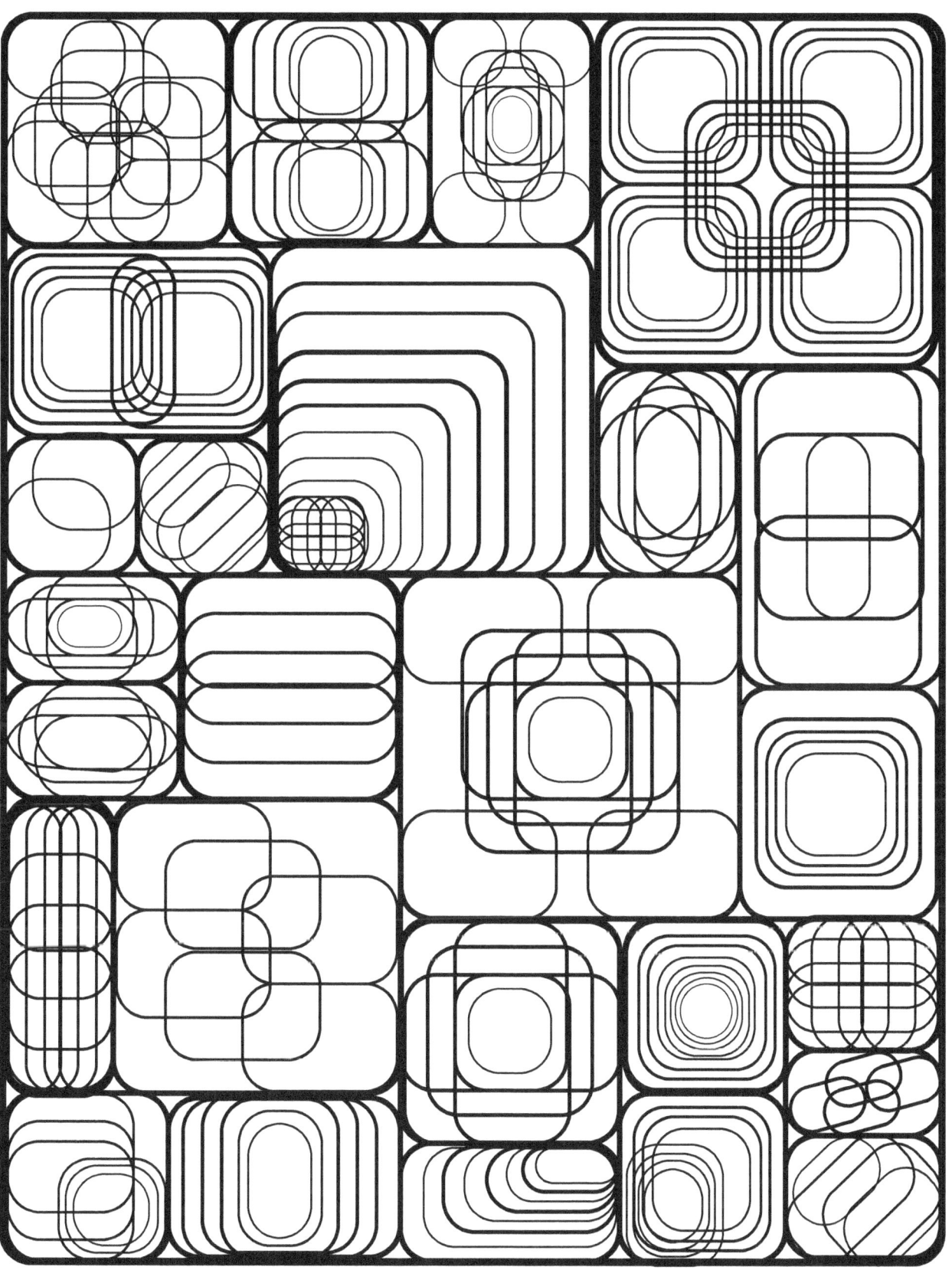

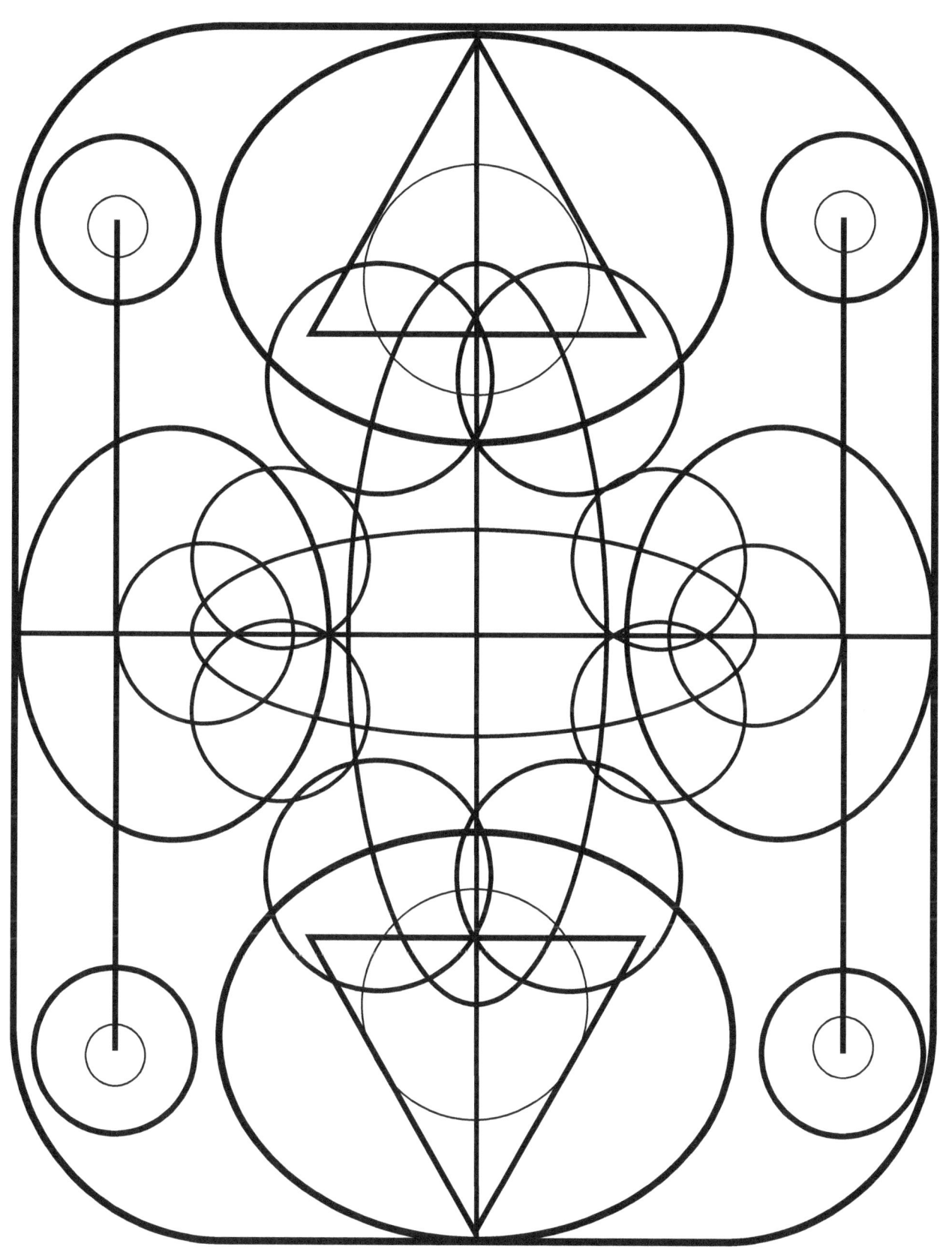

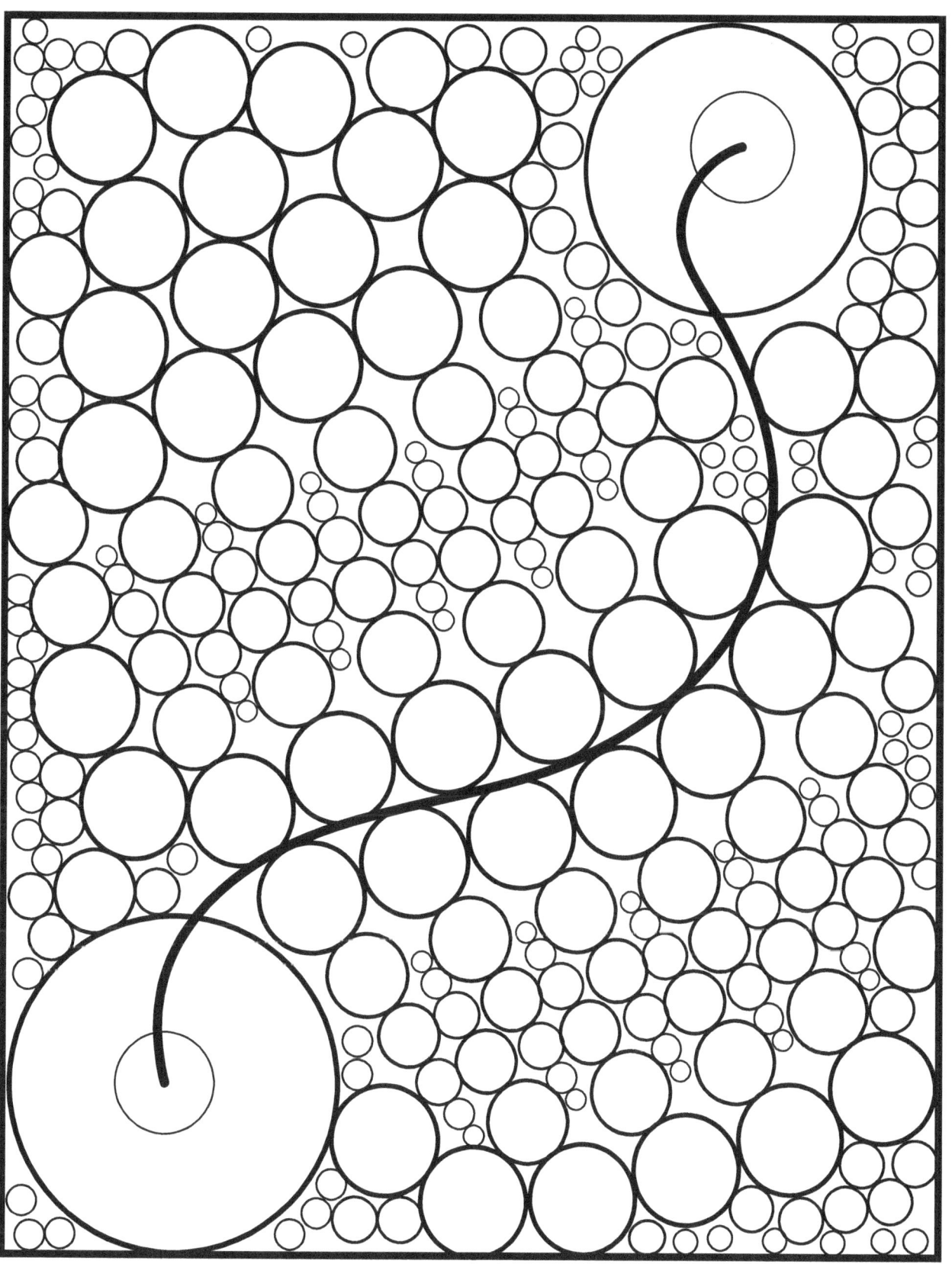

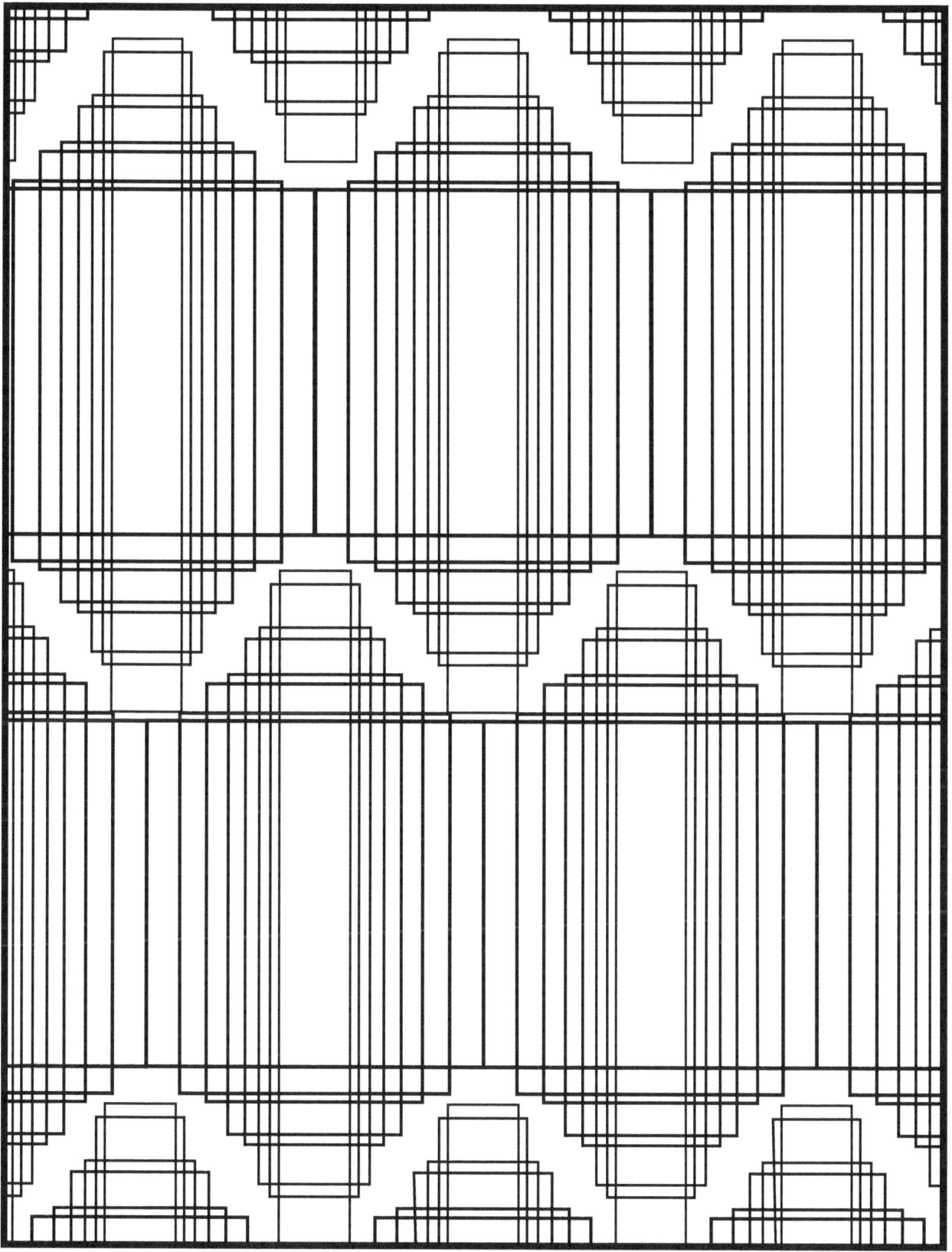

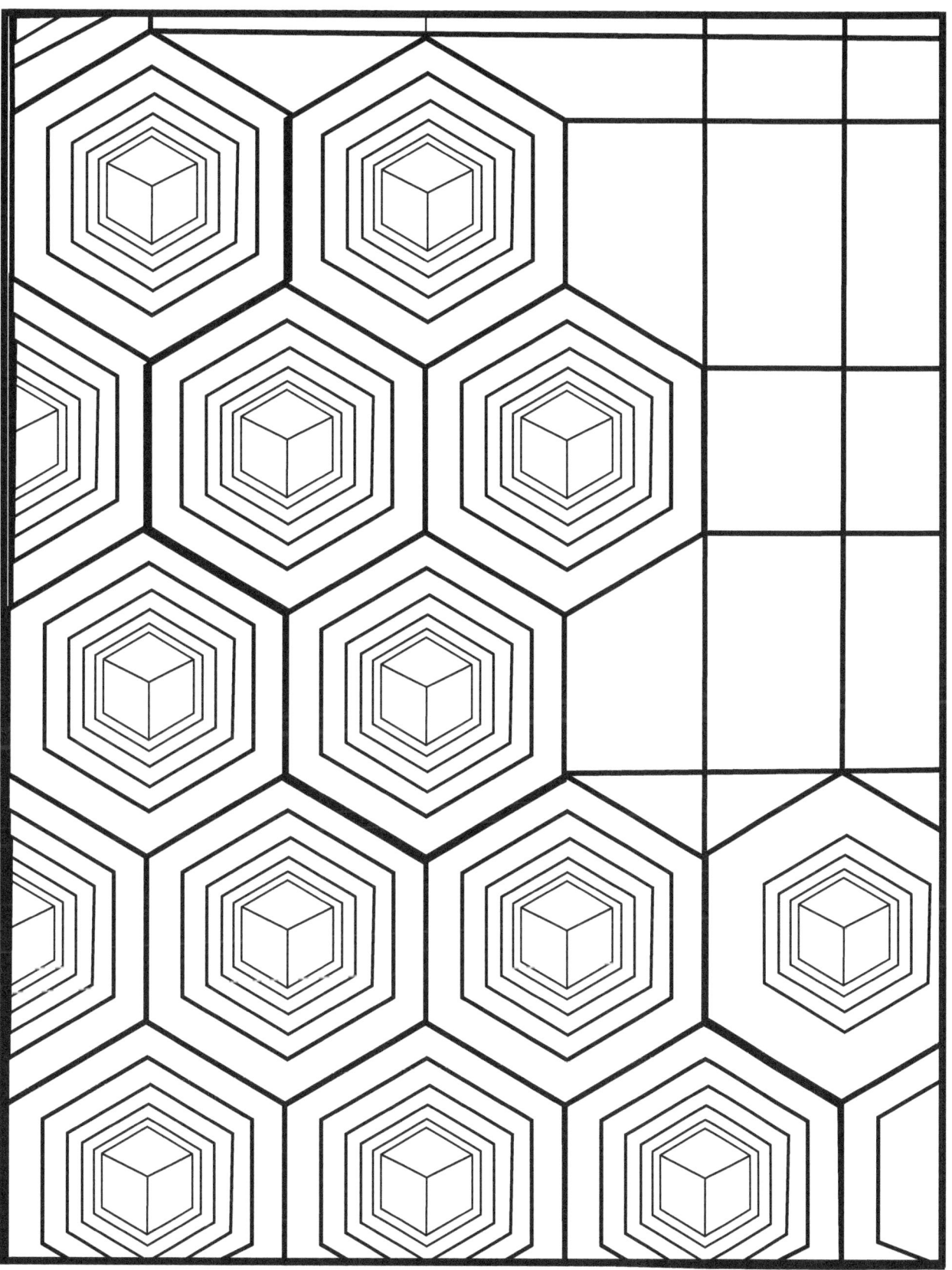

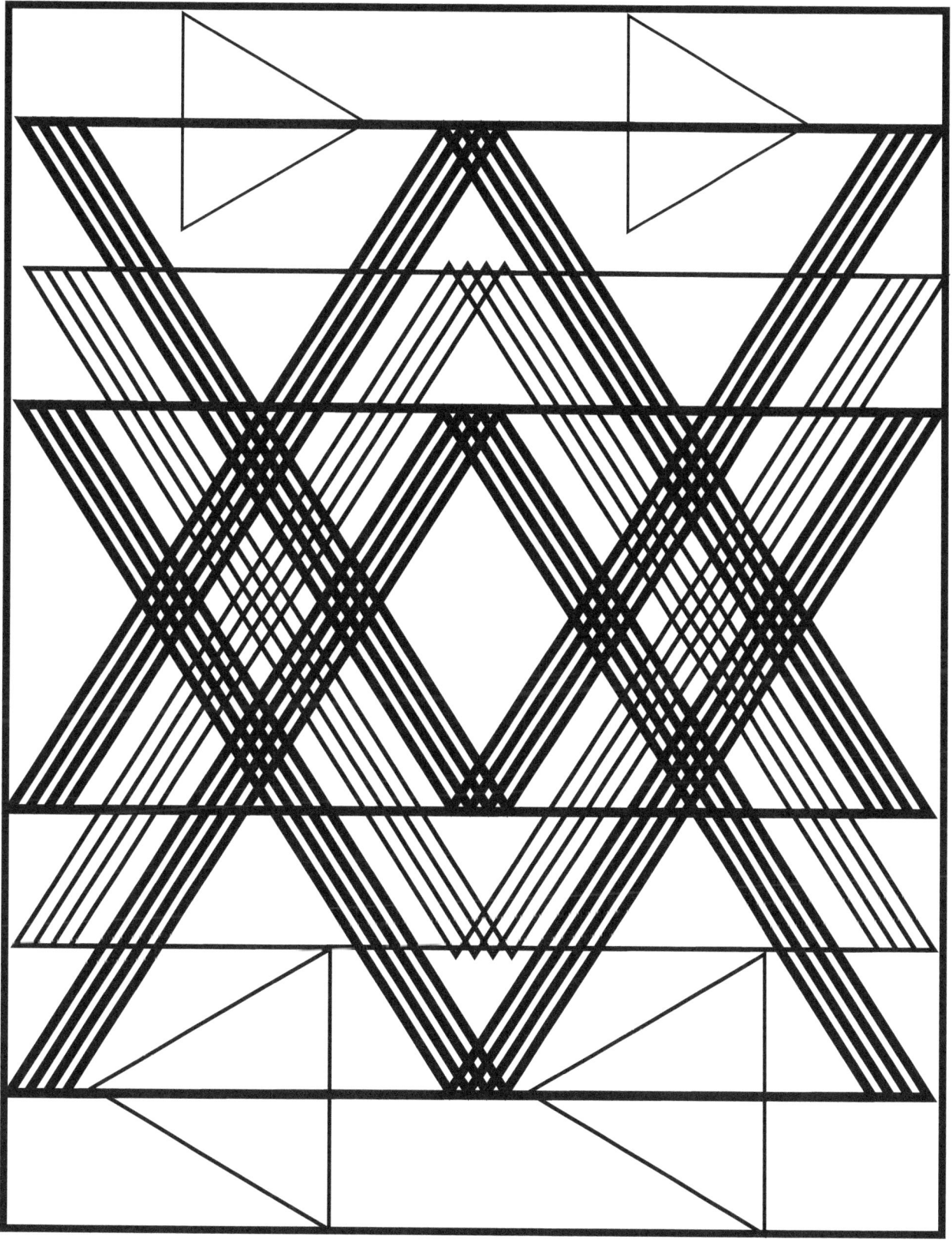

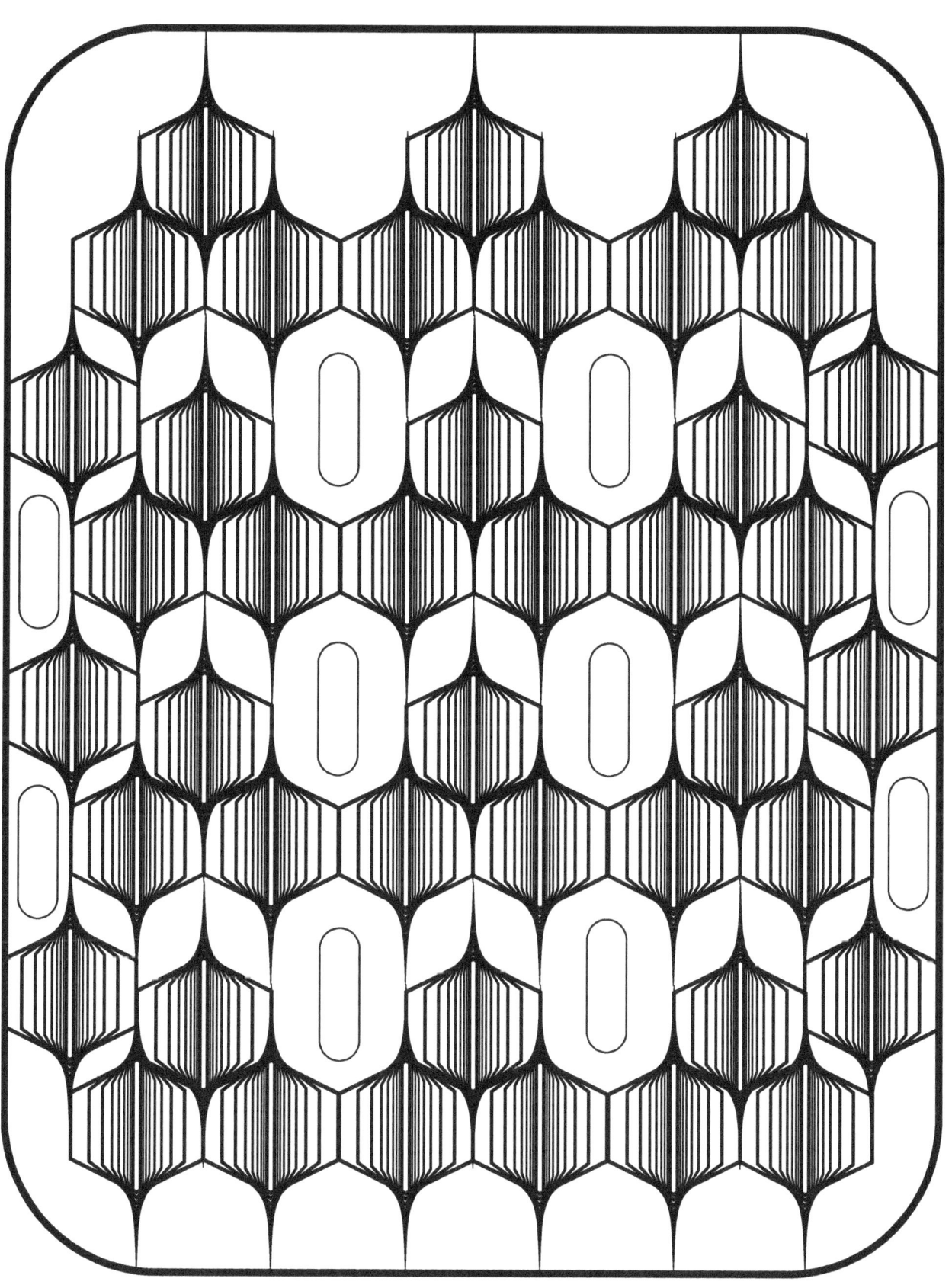

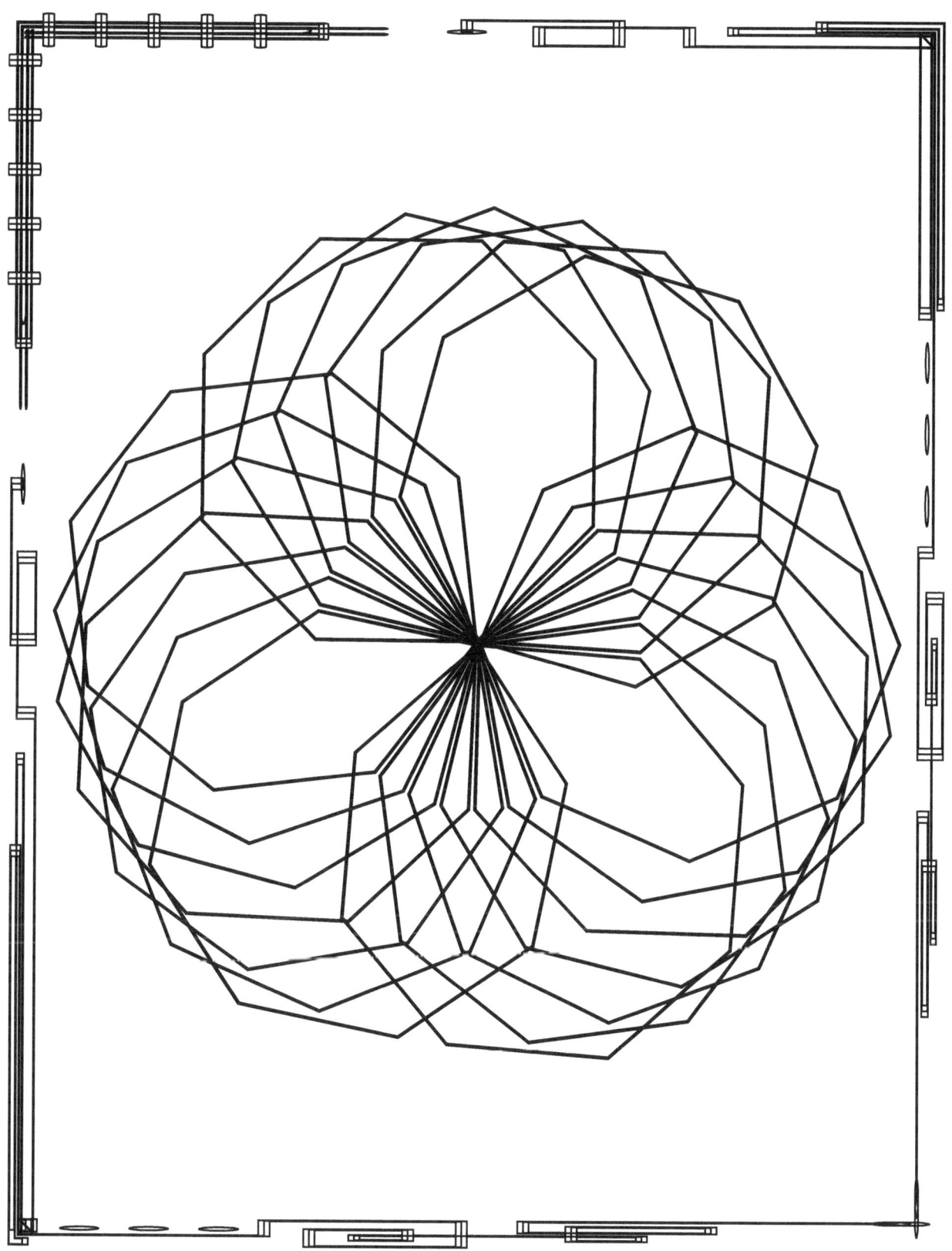

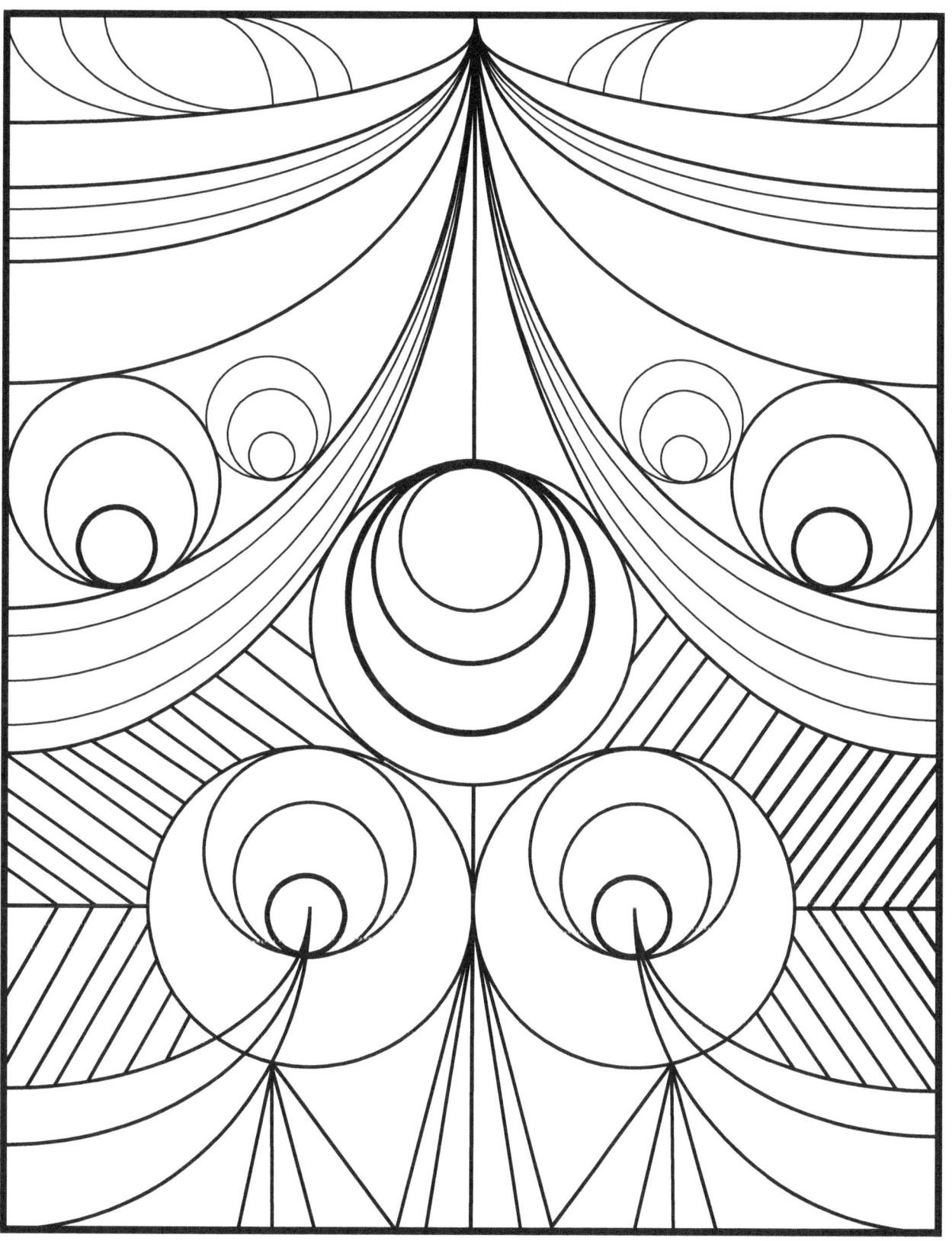

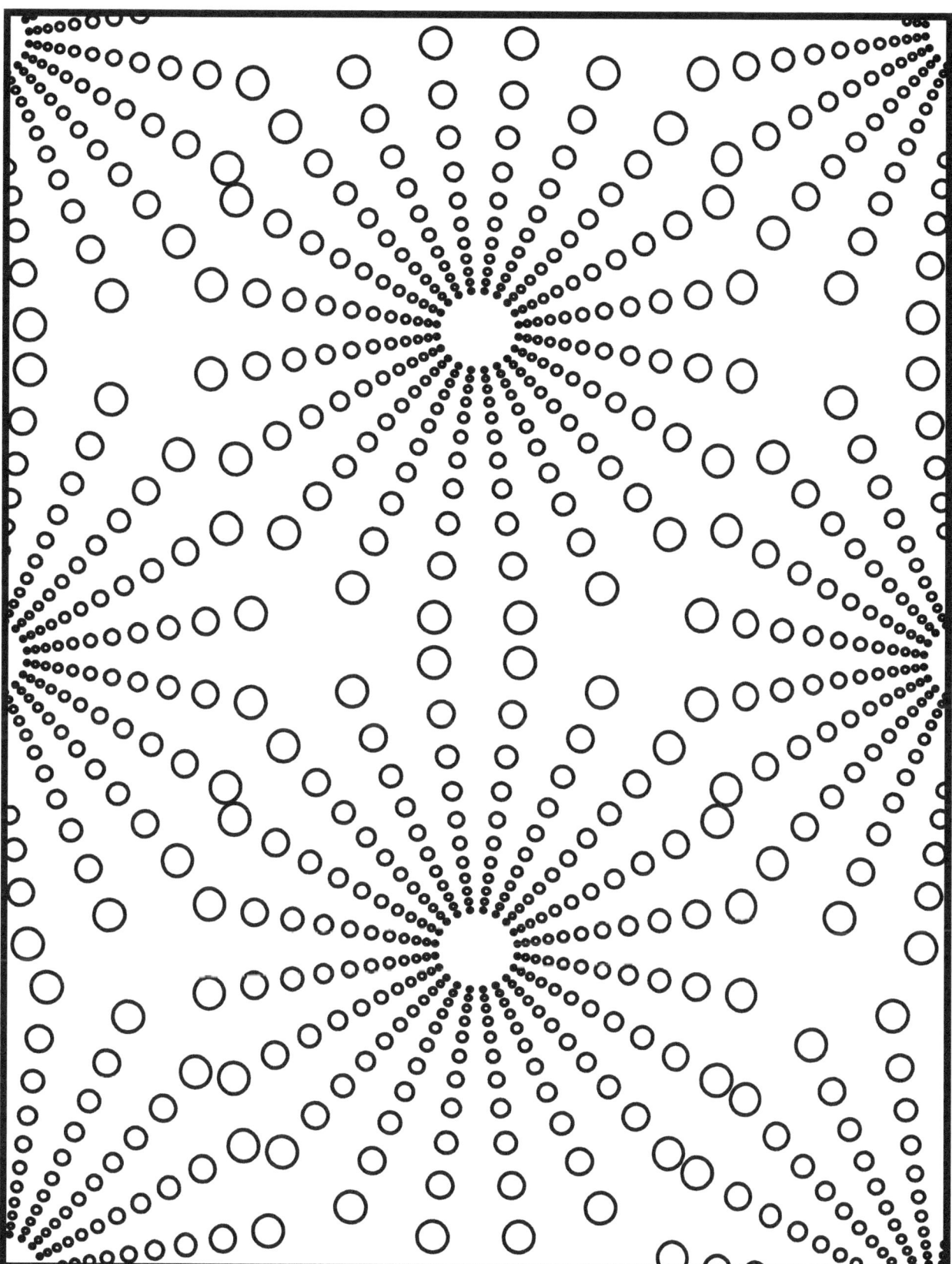

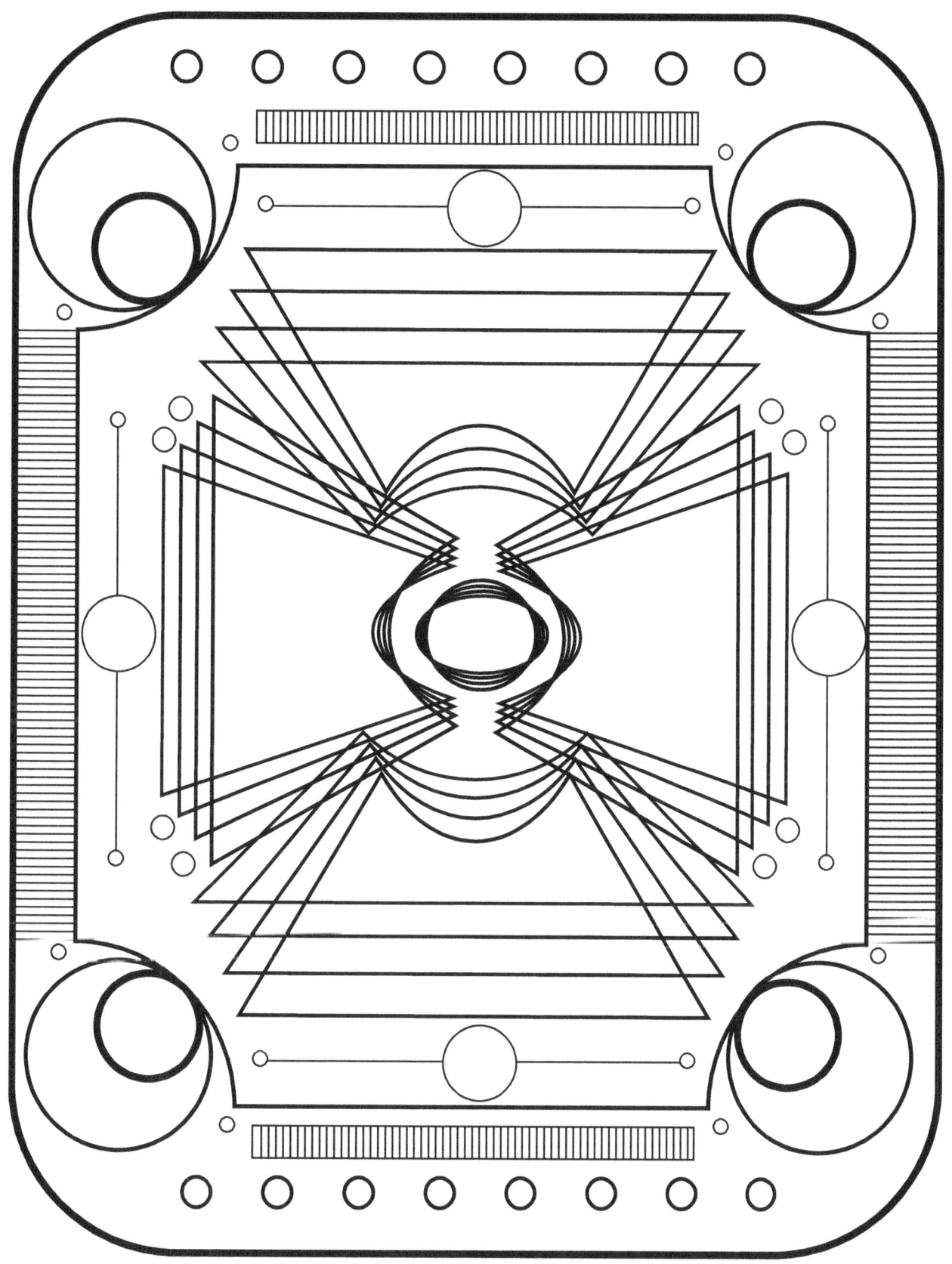

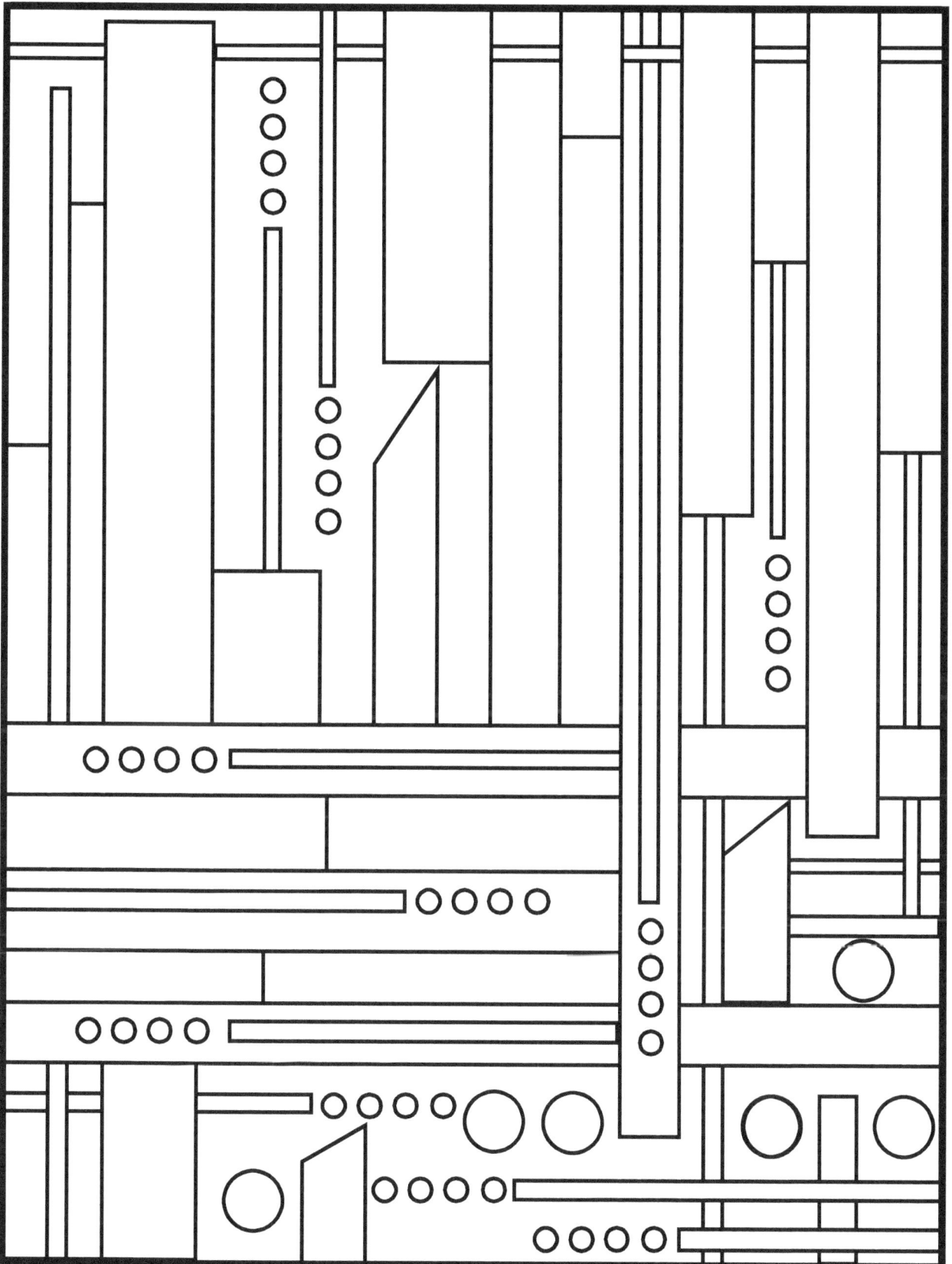

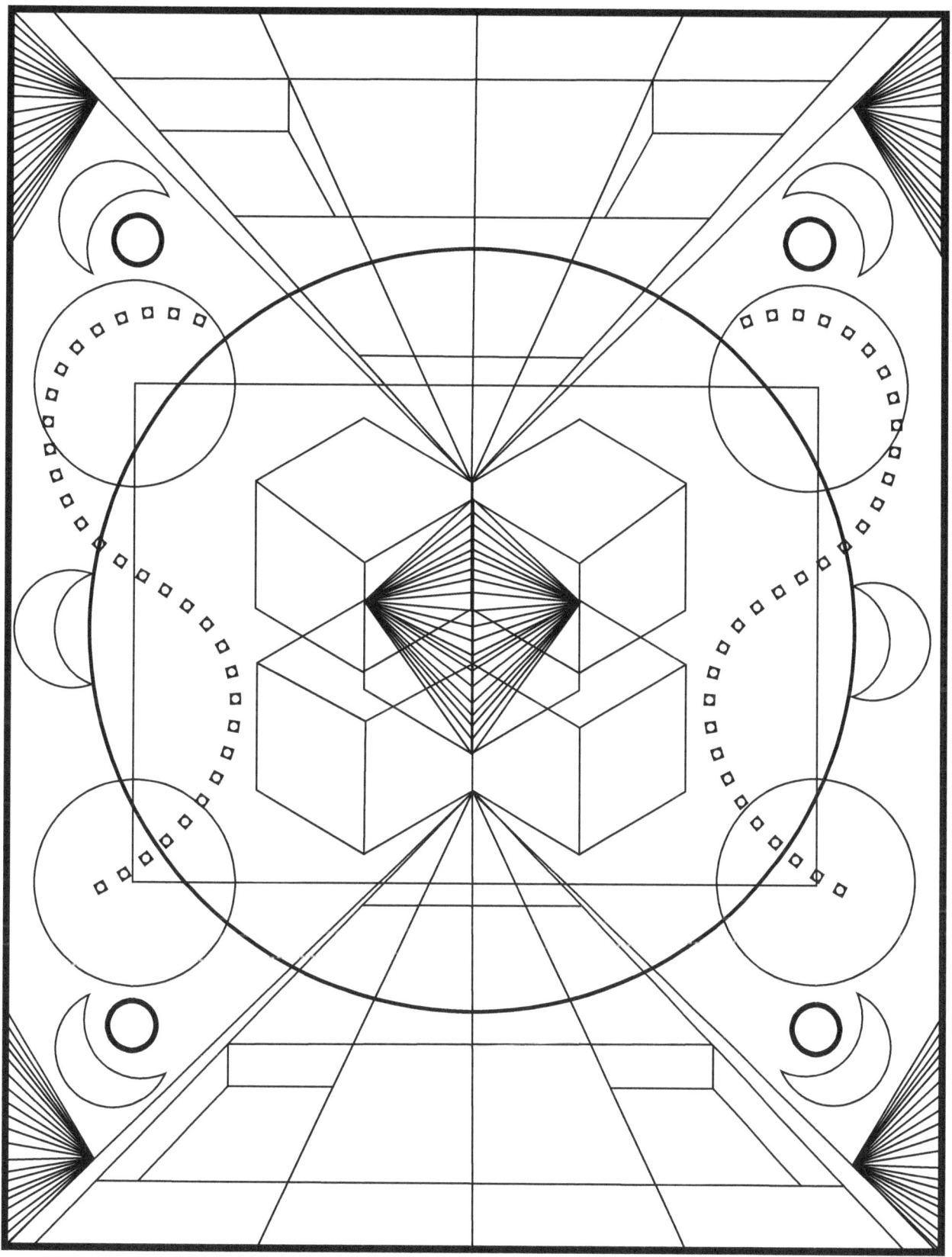

Let's stay connected!

www.InspiringExpressionDesigns.com

https://www.facebook.com/InspiringExpression/

https://www.pinterest.com/inspiringexpres/

https://twitter.com/Inspiring_Expre

https://www.instagram.com/InspiringExpressionDesigns/

www.ingramcontent.com/pod-product-compliance
Lightning Source LLC
Chambersburg PA
CBHW080715190526

45169CB00006B/2385